Artist's Photo Reference
BUILDINGS & BARNS

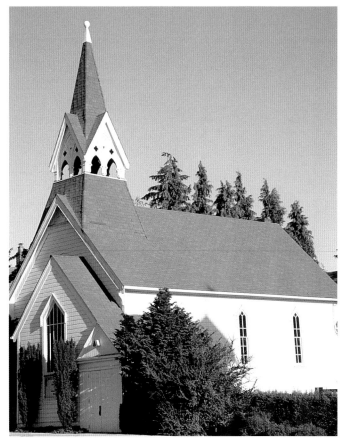
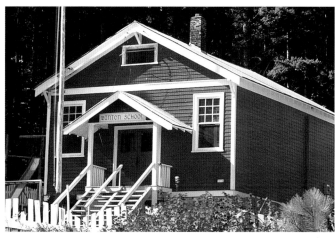
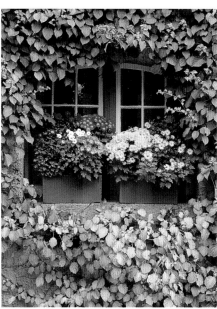
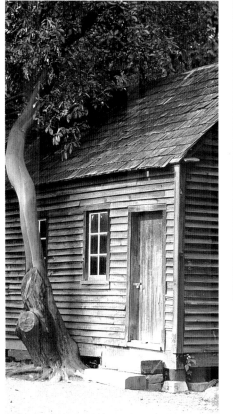
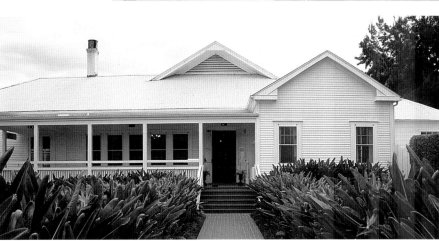

Artist's
Photo Reference
BUILDINGS & BARNS

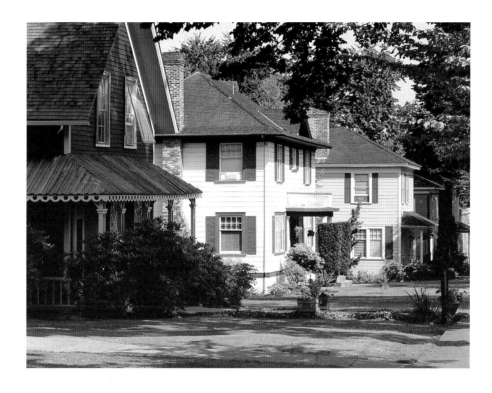

GARY GREENE

NORTH LIGHT BOOKS
CINCINNATI, OHIO
www.nlbooks.com

In addition to being an accomplished professional photographer for over twenty years, Gary Greene is a talented fine artist, graphic designer, illustrator, author and instructor. Specializing in outdoor photography, Gary's photographs have been published by (among many others) the National Geographic Society, Hallmark, US West Direct, the Environmental Protection Agency (EPA), Hertz, the Automobile Association of America (AAA), *Petersen's Photographic* magazine, *Popular Photography* and *Oregon Coast* magazine. Gary has worked in a number of fine art mediums, including acrylic, airbrush, graphite and ink. He discovered colored pencil fifteen years ago and it was love at first stroke!

In addition to *Artist's Photo Reference: Buildings & Barns*, Gary is the author of *Artist's Photo Reference: Landscapes*, *Artist's Photo Reference: Flowers*, *Creating Textures in Colored Pencil*, *Creating Radiant Flowers in Colored Pencil* and *Painting With Water-Soluble Colored Pencils*, all published by North Light Books. Both Gary's colored pencil paintings and photographs have won numerous national and international awards. Gary has conducted workshops, demonstrations and lectures on photography and colored pencils since 1985.

METRIC CONVERSION CHART

to convert	to	multiply by
Inches	Centimeters	2.54
Centimeters	Inches	0.4
Feet	Centimeters	30.5
Centimeters	Feet	0.03
Yards	Meters	0.9
Meters	Yards	1.1
Sq. Inches	Sq. Centimeters	6.45
Sq. Centimeters	Sq. Inches	0.16
Sq. Feet	Sq. Meters	0.09
Sq. Meters	Sq. Feet	10.8
Sq. Yards	Sq. Meters	0.8
Sq. Meters	Sq. Yards	1.2
Pounds	Kilograms	0.45
Kilograms	Pounds	2.2
Ounces	Grams	28.4
Grams	Ounces	0.04

Other fine North Light Books are available from your local bookstore, art supply store or direct from the publisher.

05 04 03 02 01 5 4 3 2 1

Library of Congress Cataloging-in-Publication Data
Greene, Gary.
 Artist's photo reference: buildings & barns / by Gary Greene.
 p. cm.
 Includes index.
 ISBN 1-58180-001-0 (pob : alk. paper)
 1. Painting from photographs—Technique. 2. Buildings in art. 3. Architecture—United States—Pictorial works. I. Title.

ND1505.G74 2001
704.9'44—dc21 00-060538
 CIP

Editor: Amy J. Wolgemuth
Cover and interior designer: Wendy Dunning
Interior production artist: Lisa Holstein
Production coordinator: John Peavler

ACKNOWLEDGMENTS

Sincerest thanks to Nikki Farias and Bryna Patton who directed me to several photogenic barns that I never would have found on my own. A very special thank-you to Roy and Teri Inouye, Pam and Terry Zubrod, and Jene and Paul Gallegos, who graciously took the time to drive me around their neighborhoods to shoot many of the barns and buildings in this book. Thanks also to Skip Smith of Smith-Western Company for allowing me to use images I had made for them on a prior assignment and to Prolab for their excellent, timely work. Finally, thanks to my wife, Patti, for her assistance and support.

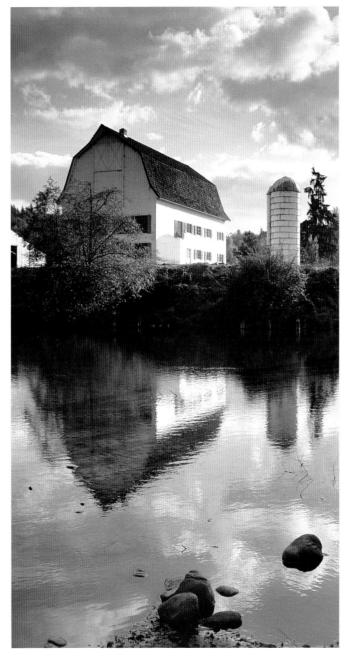

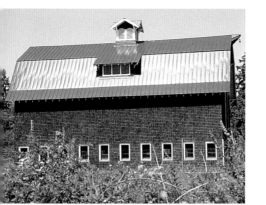

TABLE OF CONTENTS

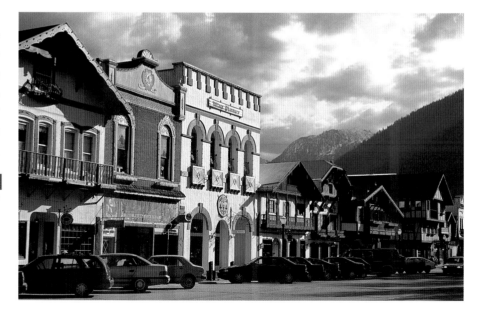

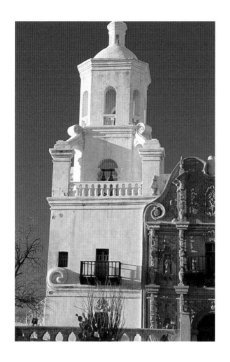

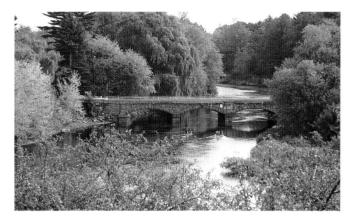

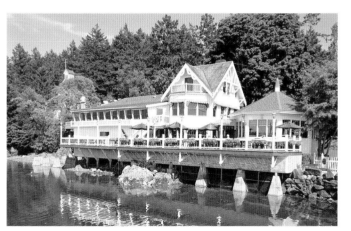

For this book, my third *Artist's Photo Reference* book for North Light Books, I combed the countryside for barns, houses and other interesting architectural edifices and photographed them specifically for you, the artist, to use as references for your paintings. The photographs in *Artist's Photo Reference: Buildings & Barns* are meant to save you time when you are looking for suitable subjects, to provide subjects that may not be accessible and to supplement your own collection of reference photos. Many of the subjects are shown from different angles and with close-up views to aid in your understanding of the buildings' structures and textures. These images may be freely used as references but not copied and publicly exhibited or sold as original artwork.

The subjects in this book were photographed in various regions of the United States, providing a variety of architectural styles, shapes and textures to choose from. As urban areas encroach into the countryside and as farming has become increasingly more big-business oriented, picturesque wooden barns of yesterday are either being replaced with not-so-picturesque metal structures or disappearing entirely, making finding just the right barn for your country painting difficult.

The numerous types of buildings in this book include storefronts, churches, lighthouses and a variety of other structures. There are also reference photos of bridges, outdoor stairways, gazebos and other structures that will keep you in reference material for a long time. Skyscrapers, modern office buildings and highly recognizable structures, such as the Golden Gate Bridge, have been omitted because it is relatively easy to find reference material on these structures, and they cannot be adequately represented due to limited space.

Interspersed throughout *Artist's Photo Reference: Buildings & Barns* are six step-by-step demonstrations by professional artists, using their mediums of expertise, to show how they've interpreted featured reference photos. These demos should also provide you with additional inspiration.

To broaden your horizons, use this book along with *Artist's Photo Reference: Landscapes* to enhance your possibilities and create beautiful landscape paintings.

Gary Greene
Woodinville, Washington
January 2000

Do you enjoy painting rural scenes, quaint Victorian cottages or lighthouses on rocky beaches? Do you have reference photos of these scenes? You probably won't have lighthouses if you live in Kansas, so you'll have to either take a trip to the seashore or to your local library where you'll pore over stacks of useless books and magazines for lighthouse references. Instead, you can simply open this book and find exactly what you need. The purpose of the *Artist's Photo Reference* series is to provide you, the artist, with reference photographs.

Properly Using This Book

The proper use of *Artist's Photo Reference: Buildings & Barns* requires that the photographs herein not be copied exactly as they appear, especially if you intend to publicly display, reproduce or sell the artwork. However, you may freely borrow from a particular reference photo and change your painting enough so it can't be identified as being the same as the original. For example, you should select a barn from a reference photo, add clouds and mountains from other sources, change the lighting, crop the composition—you get the picture. A good source for landscape elements is my companion book *Artist's Photo Reference: Landscapes*. Many of the reference photos in *Buildings & Barns* are intended to depict specific elements of structures and are not necessarily composed correctly or photographed under optimal lighting.

Composite reference photos may be compiled by making photocopies of the images in this book, cutting out the elements you want from the copies and pasting them together to form a collage.

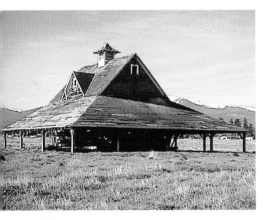

Primary photo

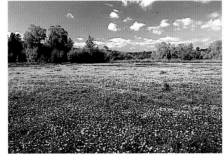

Secondary photos

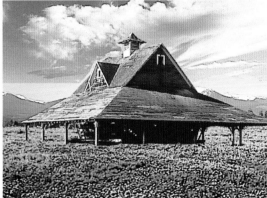

Final composite photo

You may want to make an enlarged copy of the pasted-up original, but keep in mind that repeated generations of copies yield poor color and loss of detail. Copy centers may be reluctant to reproduce images from this book because of copyright concerns. If this happens, show them this: **Hey, copy person: It's OK to photocopy the pictures in this book!**

If you are computer savvy, programs like Adobe Photoshop can make creating composites a much cleaner process. Photos can be scanned, cut and pasted together electronically. Your electronic composite can be printed on a laser color copier at your favorite copy center, or printed on your own color copier.

Remember that personal inkjet printers produce copies with poorer color and resolution than laser copiers. When using composite photos as subjects, make sure your painting is in proper perspective, the lighting is consistent and everything is drawn to the same scale.

How Pros Interpret the Photos

Interspersed throughout this book are demonstration paintings created by master artists working in each of the major art mediums—acrylic, colored pencil, mixed media, oil, pastel and watercolor. These demonstrations show how professional artists creatively used the reference photos.

Making Your Own Reference Photos

Many artists are put off by photography. They're not only missing a chance to improve their artwork, but they're also missing the creative possibilities of a truly exciting medium. Photography is often thought to be difficult and technical, but it's actually easier to achieve good photographic results with a basic knowledge of this medium than with years of instruction and practice with painting!

Although photography can be expensive, it's not necessary to spend a great deal of money to get good reference photos. A manual-focus, single lens reflex (SLR) camera and a moderate zoom lens can cost as little as $225. A sturdy tripod with a standard pan head will cost about $75, and a filter to protect your front lens element will be around $20. This basic outfit should be sufficient, unless the shutterbug bites you!

Equipment: Basics and Beyond

A *35mm SLR camera* featuring interchangeable lenses is a must. So-called point-and-shoot cameras are not recommended because their optics may be inferior, or they may allow little or no control over exposure, focal length or focus. APS (Advanced Photo System) cameras are fine for snapshots but they use film that is smaller than 35mm, which is not a good film for sharp, detailed images.

The camera you choose need not be an autofocus model, unless you intend to shoot moving objects. Camera bodies are usually sold separately without lenses. Avoid package deals because unscrupulous dealers often offer inferior lenses and other equipment with camera bodies.

Lenses come in a variety of focal lengths and speeds. They may be made by the camera's manufacturer or by manufacturers who specialize in producing only lenses. Independently made lenses are less expensive than the camera maker's and are, for the most part, comparable in optical quality.

A lens' *speed* denotes how much light-gathering power it has. As the speed of the lens increases, so does its size and price. A fast lens is not necessary for architectural photography, especially if you use a tripod.

A *zoom lens* will give you a variety of focal lengths built into one lens. With today's technology, zoom lenses have excellent optics, greater zoom ranges, and are smaller, lighter and faster. An ideal zoom lens has a 28–200mm focal length, which should be suitable for 95 percent of all the photos you'll want to take.

It's important to know that photographing a building with a wide-angle lens will produce a distorted perspective. This distortion becomes more pronounced as you tilt the camera up or down and as the focal length decreases

(wider angle). This distortion should be compensated for when you are laying out your painting.

Filters screw onto the end of the lens and perform various specialized functions. You should always have a filter on your lens to protect its front element from dust and scratches. Many photographers use a clear UV or skylight filter, but an 81A filter is strongly recommended. Slightly orange in color, the 81A filter warms up your color photos (particularly slides) without altering them and is useful on overcast days.

A *polarizing filter*, or polarizer, is a rotating filter that removes glare, intensifies skies and produces richer color. Polarizers work optimally at 90-degree angles from the sun and have less of an effect as you face the sun or have your back to it. Manual-focus cameras use *linear polarizers* and autofocus ones require the circular variety.

Tripods are the bane of most amateur photographers because tripods are

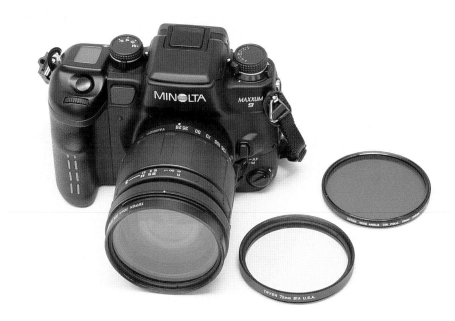

Lenses are available in a variety of focal lengths and speeds. The zoom lens on the SLR camera shown above (with polarizing filters) has a focal length of 28–200mm, which should be suitable for 95 percent of the pictures you'll want to take. Quick-release ball-head tripods like the one shown on the right allow for easy movement without the hassle of levers.

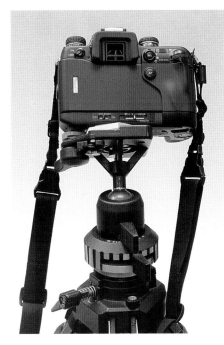

clumsy, heavy and sometimes complicated to use. The bad news is that you'll need a tripod to get sharp, detailed pictures. The good news is that a tripod equipped with a ball head and quick release instead of a standard pan head can mitigate some of the hassles in using a tripod. Ball heads are like a universal joint and allow you to easily move the camera into any position without fumbling with levers. A quick release has a small plate that attaches to the bottom of your camera and frees you from using the screw mount to attach and release your camera from the tripod. Place the camera plate to the receptacle on the tripod, and snap, it's locked onto the tripod. Release it by flipping a lever. Extremely lightweight carbon-fiber tripods are also available. Weighing about half as much as a comparable standard tripod, these models are equal in strength but unfortunately cost four or five times as much.

Film is to the Photographer What Paint is to the Artist

Because there are so many film choices, choosing the right film can be intimidating to the fledgling photographer. Should I use print or slide film? Fast film or slow film? Which brand of film is best? There are no easy answers because film choice can be as personal as choosing between brands of oils and watercolors.

The following are recommendations to help you choose the right film. *Slides* are preferable to prints for several reasons. For one, slide or transparency film produces images that are sharper and much more color-correct. Many artists work directly from slides viewed through an inexpensive photographer's loupe. Slides are less expensive and less of a storage problem, and prints made from slides (called "R" prints) are comparable to prints from negatives.

Print film is more forgiving than slide film, because you can miss the correct exposure by a greater margin and still have a good photo. However, print film is more vulnerable to printing errors in the lab, resulting in poor color, incorrect exposure, or both.

A *film's speed* (ISO) determines how sensitive it is to light. The faster the film (the higher the ISO number), the more sensitive it is, which enables the photographer to shoot at higher shutter speeds, making a tripod unnecessary. However, faster film has larger light-gathering particles in its emulsion, which produces grainier, less-sharp photos.

Suggested slide films are Fujichrome Velvia (ISO 50) and Provia F (ISO 100), or Kodak Ektachrome E100VS or E100SW (both ISO 100). Velvia is one of the sharpest films available and produces brilliantly saturated colors, even on overcast days. E100VS is twice as fast as Velvia, has excellent sharpness

and yields colors even more brilliant than Velvia. Don't look for these professional films at your local drug or discount store; you can find them at camera stores or photo labs. Kodachrome films (ISO 25 and 64) are also good films but may take up to two weeks to process, whereas the others can be processed in as little as two hours.

A Photographer's Shopping List

Here is a list of useful equipment for taking reference photos. Approximate standard prices as of this publication are given in parentheses.

Manual-focus 35mm SLR camera ($150 & up)

Autofocus 35mm SLR camera ($200 & up)

Moderate zoom lens: 35–70mm focal length ($75 & up)

Extended range zoom lens (recommended): 28–200mm focal length ($250)

Long zoom lens (optional): 100–400mm focal length ($500)

Protective filter: Skylight or UV ($20)

Protective filter (recommended): 81A ($20)

Polarizing filter (optional): ($30 & up)

Tripod with standard pan head ($75 & up)

Tripod with ball head and quick release (recommended) ($125 & up)

Camera bag ($50 & up)

Camera vest (recommended) ($35 & up)

Hunting for Photos

Being outdoors and taking photographs can be as exhilarating as painting or drawing, doubly so if you use your own photographs as subjects! Here are a few simple guidelines for shooting successful architectural reference photos:

- Before you begin, keep in mind that unless a particular building is a private structure and part of its owner's corporate or personal identity, it's perfectly legal to photograph it as long as you are shooting from a public road or easement. However, it's *never* legal to trespass on private property! If you see a barn in a distant field, no matter how beautiful it is, you should *always* seek permission of the property owner before you walk onto their field or yard.

- *Light* is probably the most important element in any photo. As a rule, the best natural lighting occurs two to three hours after sunrise and before sunset. Sometimes called the "golden hours," this lighting is warmer and more pleasing than when the sun is overhead. It also produces a better modeling of shadow and light because of the sun's lower angle.

- When photographing buildings, try to shoot them when the sun is falling at an angle on the building. If your subject is completely in shadow or in direct sunlight, important details may be lost. If possible, return at a different time to get better lighting. If this is not possible, shoot anyway, but make sure you *bracket* your exposures with additional exposures over and under a stop from your meter reading. Doing this will increase your chance of recording important details.

- An overcast sky is unsatisfactory for architectural photography because sunlight is scattered by the overcast clouds, producing photos with flat lighting and little contrast. If you feel you can use a particular scene or element and it's overcast, shoot it anyway and then incorporate better lighting when making your painting.

- *Composition* is a consideration when shooting reference photos. You can opt to make a ready-to-paint, in-camera composition or just shoot important elements and save them for use in future paintings. If you want to compose your photograph correctly, the same rules apply to photography as in painting or drawing. The first rule is to have a *center of interest*. Use the rule of thirds. Divide your painting into thirds horizontally and vertically, and place the center of interest (a barn for example) on or near the intersections of imaginary lines delineating these zones. Second, include a *foreground, middle ground* and *background*. Use objects such as trees, bushes, rocks and so on in the foreground to lead the eye into your composition and to frame the subject.

Once you understand the basic photographic techniques, you'll not only have plenty of reference photos to work from, you'll have a better understanding of light and form and maybe even a whole new art medium to explore.

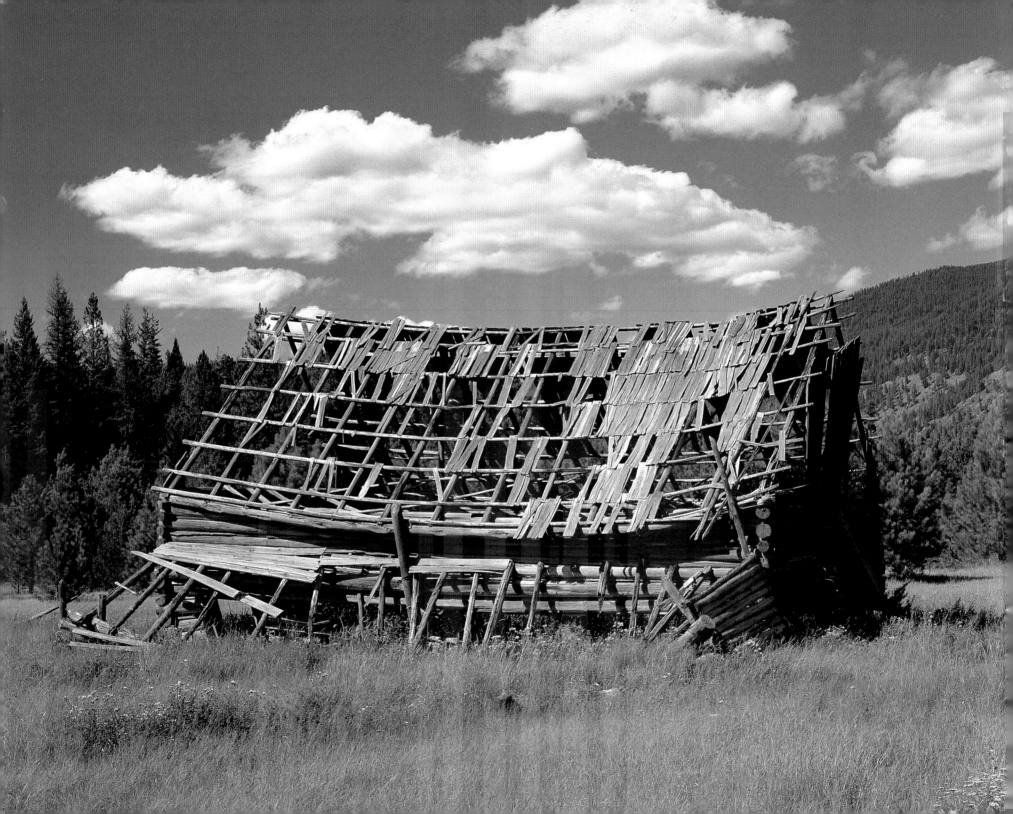

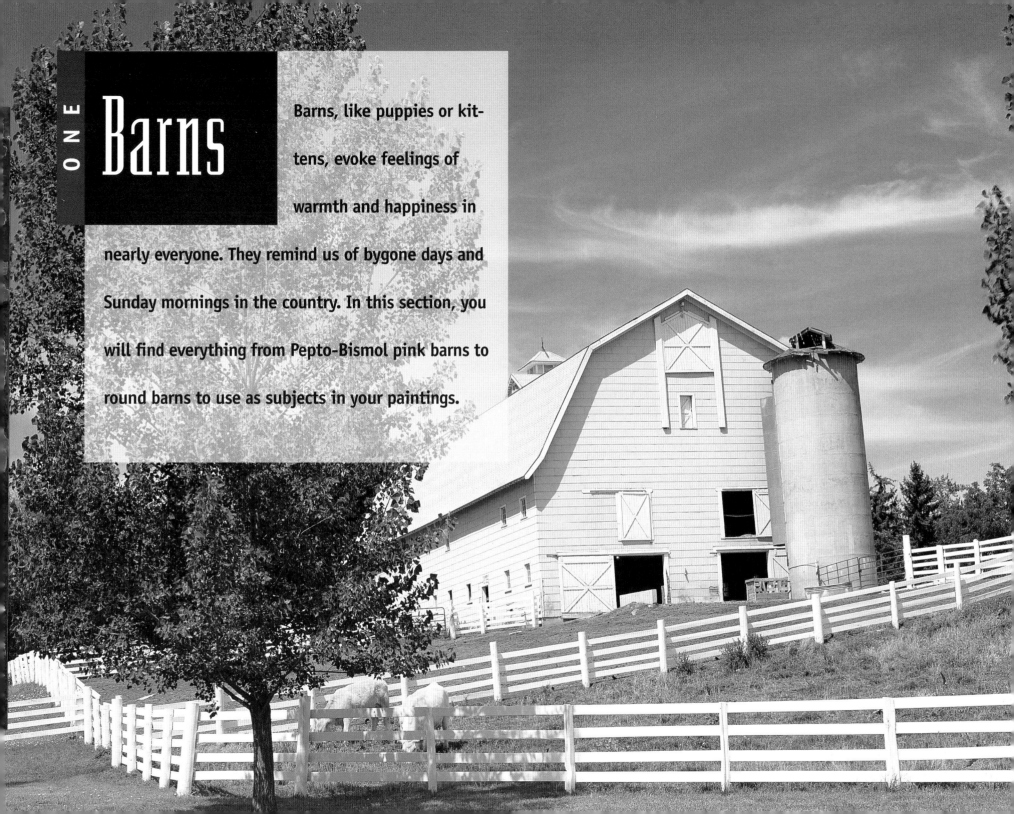

Barns

Barns, like puppies or kittens, evoke feelings of warmth and happiness in nearly everyone. They remind us of bygone days and Sunday mornings in the country. In this section, you will find everything from Pepto-Bismol pink barns to round barns to use as subjects in your paintings.

Healthy

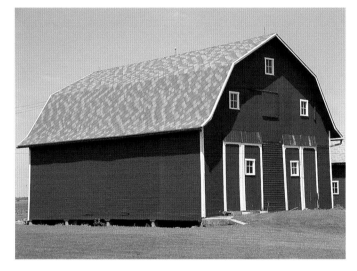

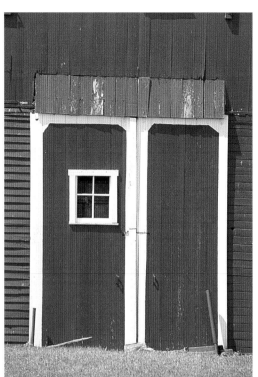

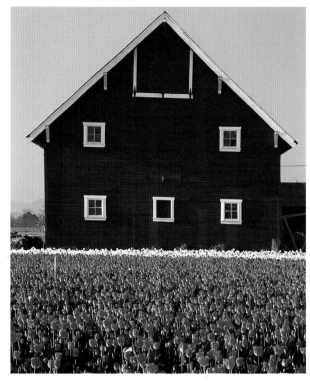

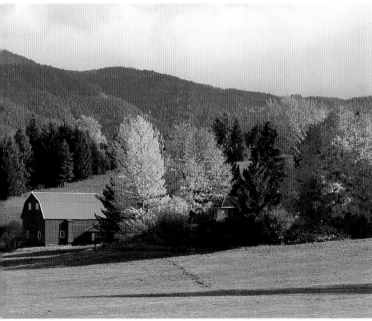

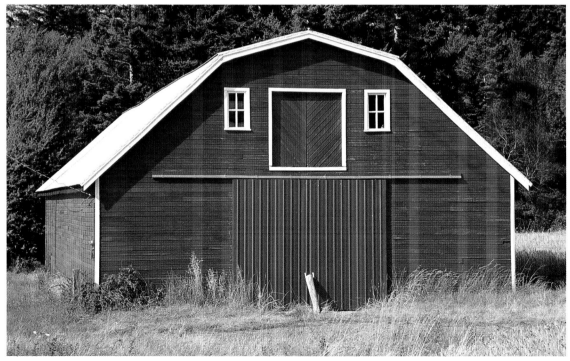

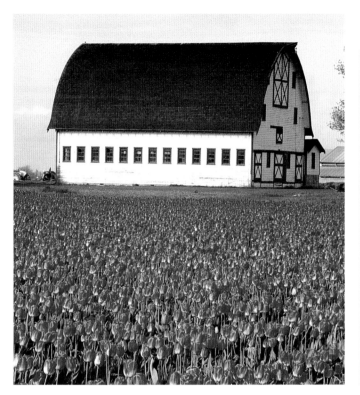

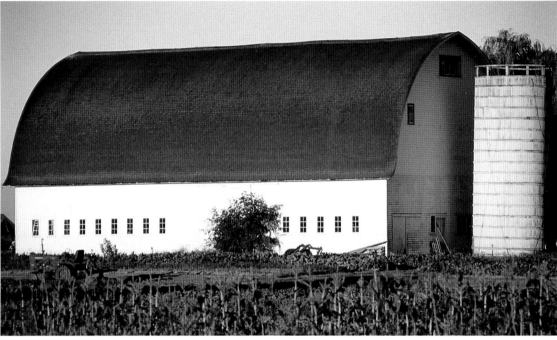

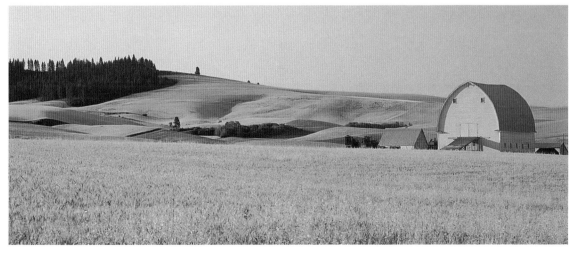

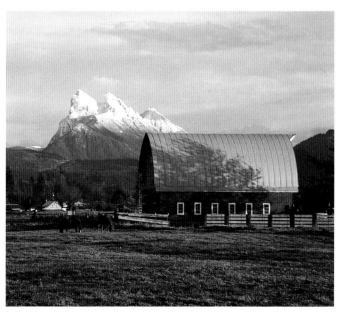

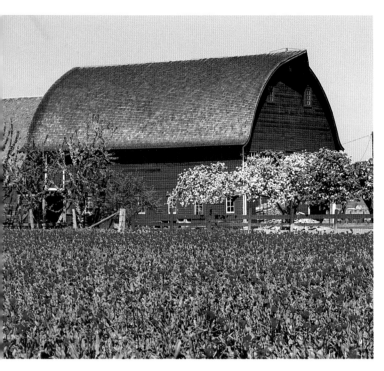

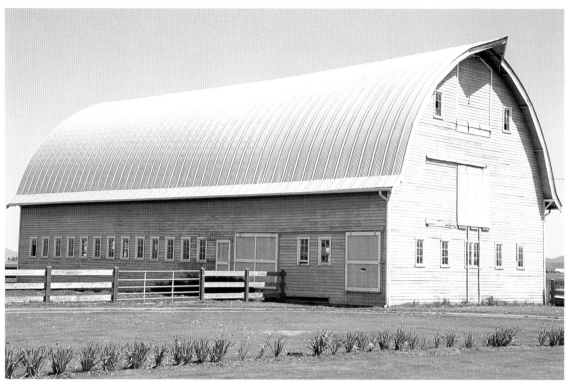

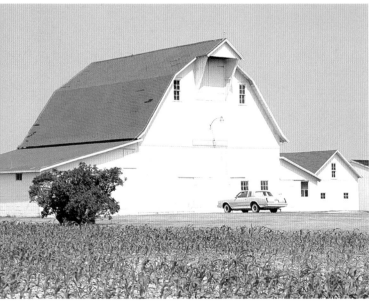

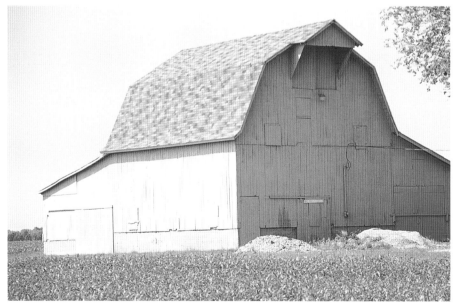

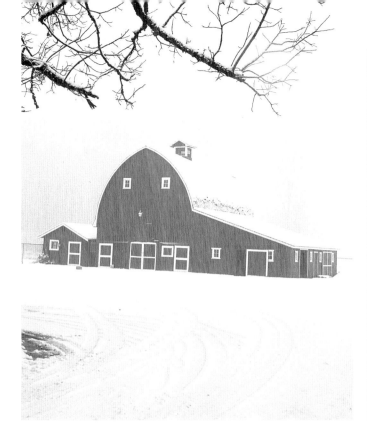

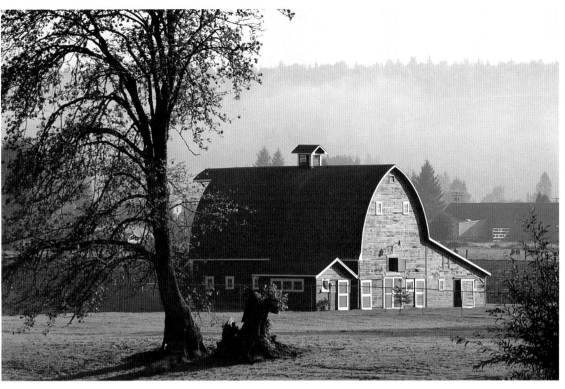

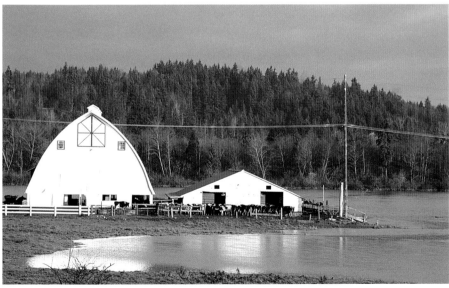

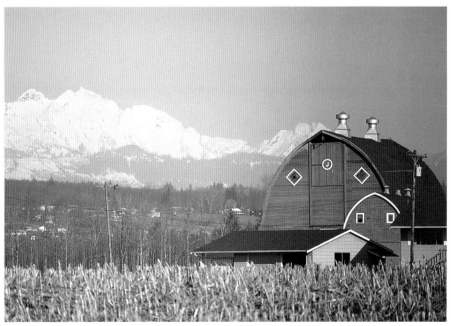

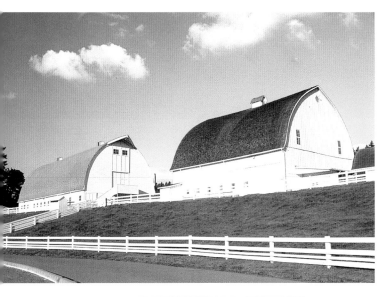

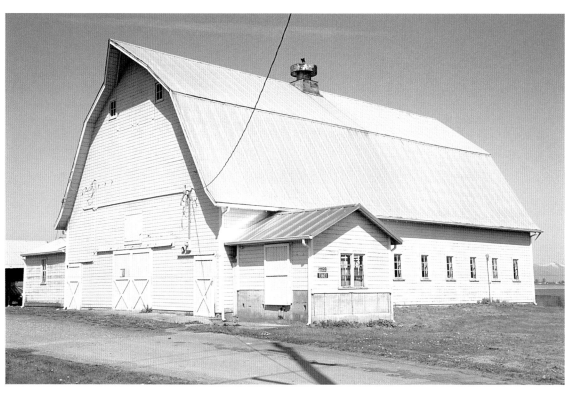

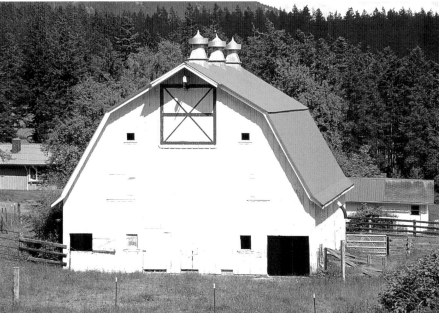

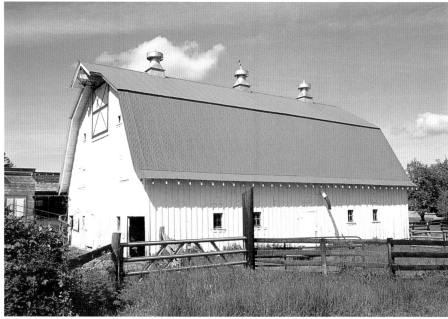

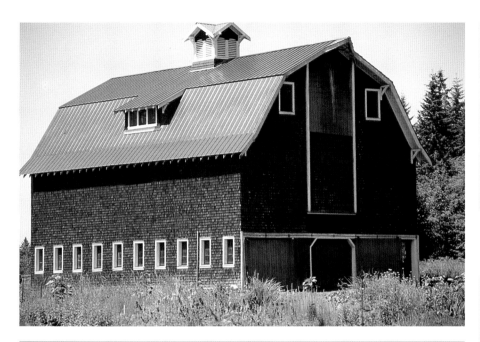

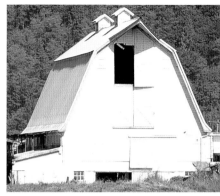

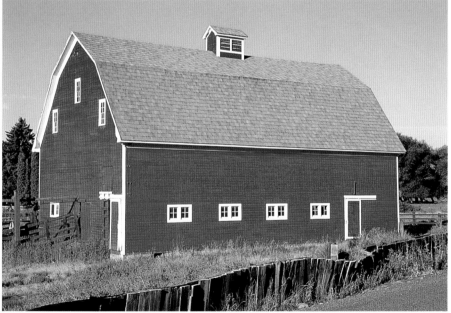

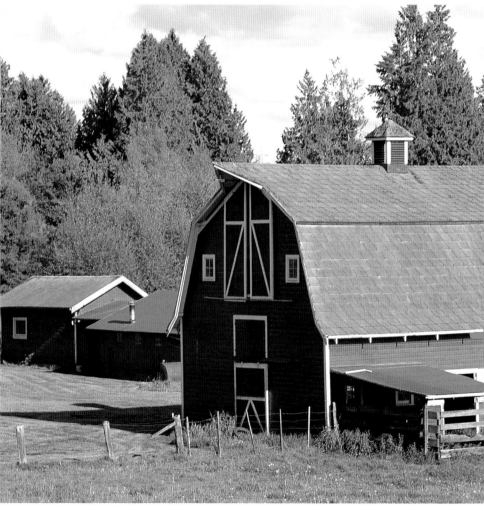

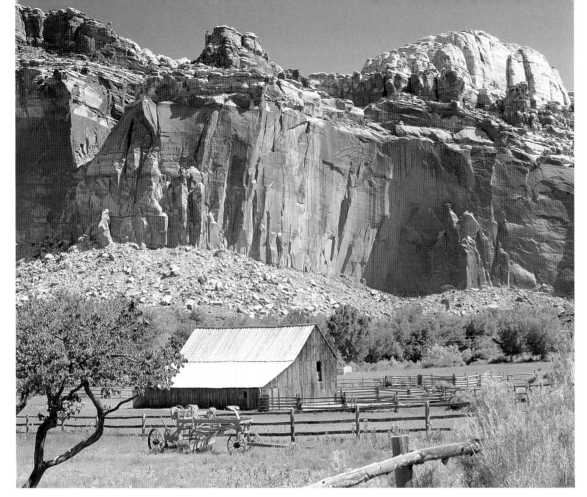

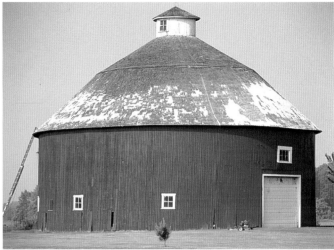

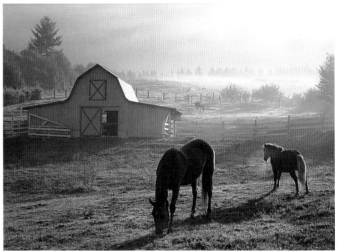

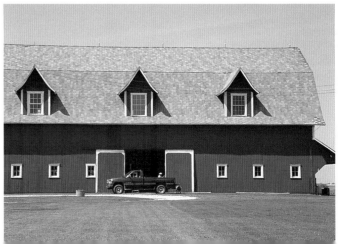

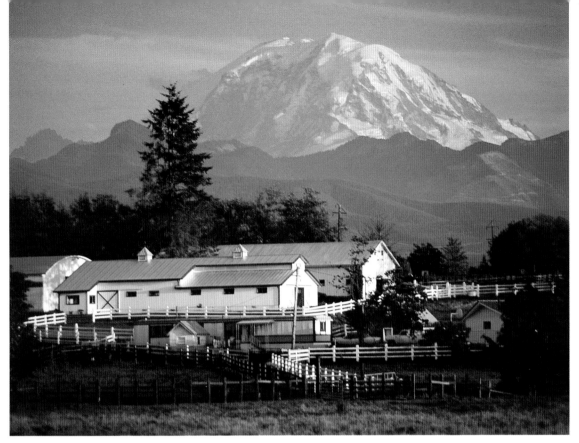
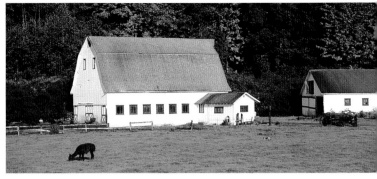
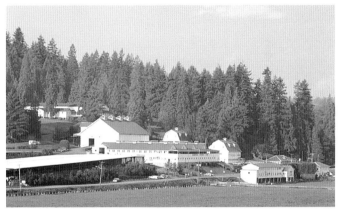
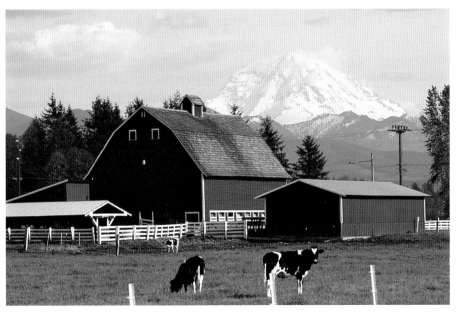
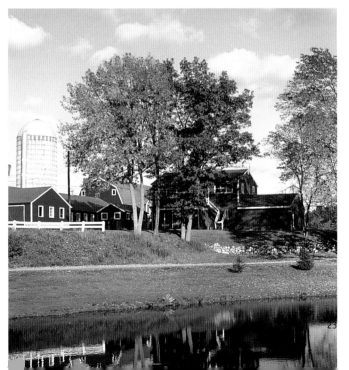

Weathered

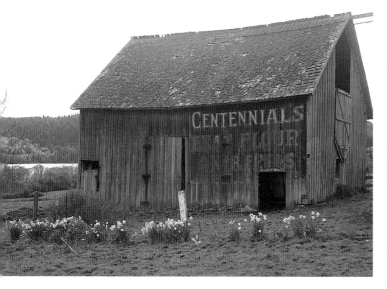

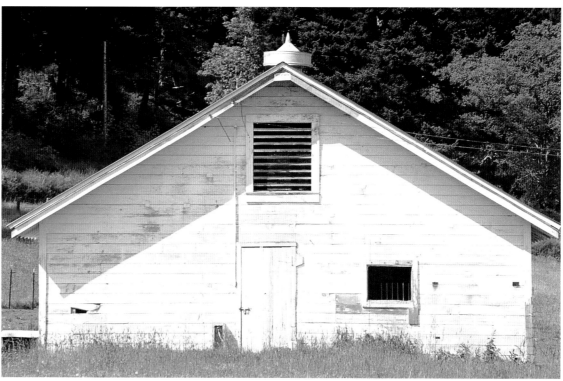

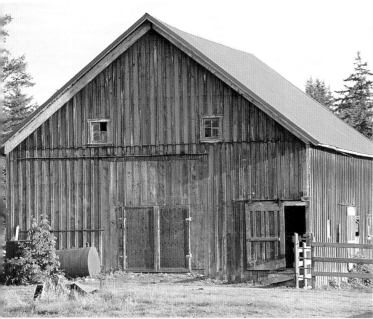

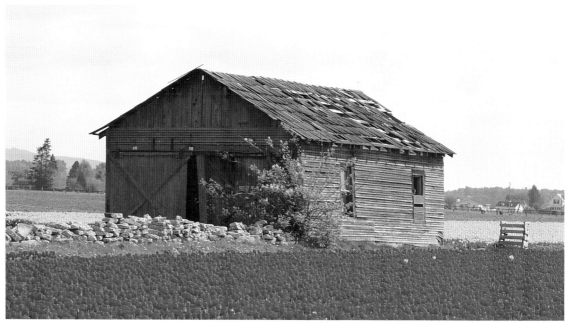

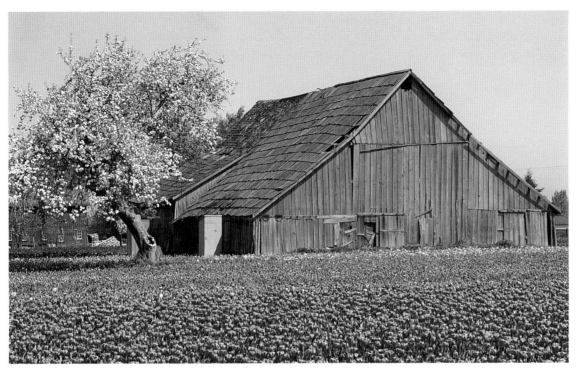

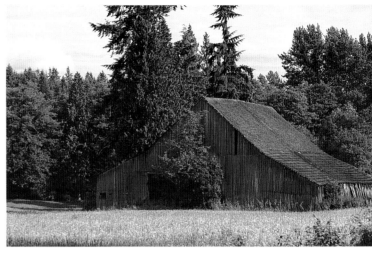

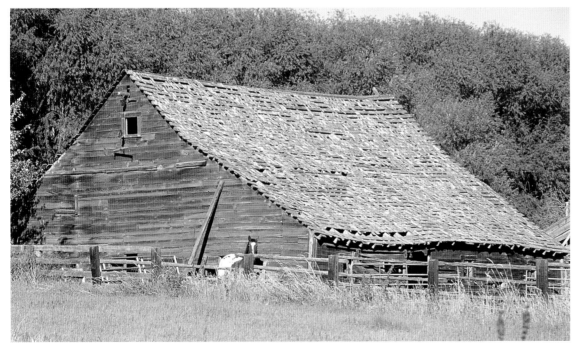

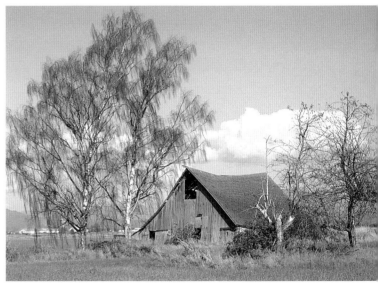

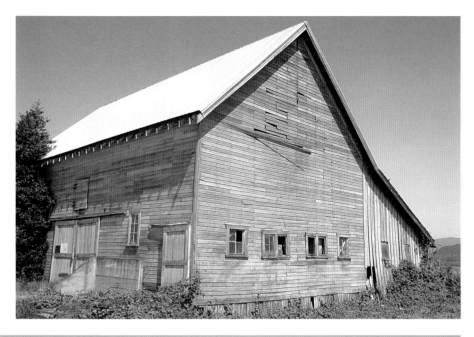

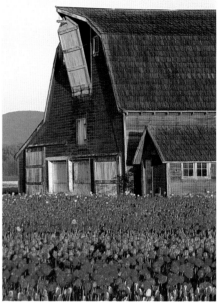

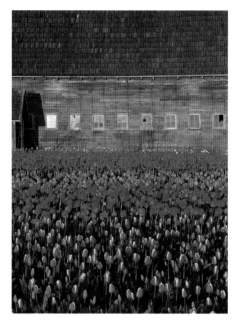

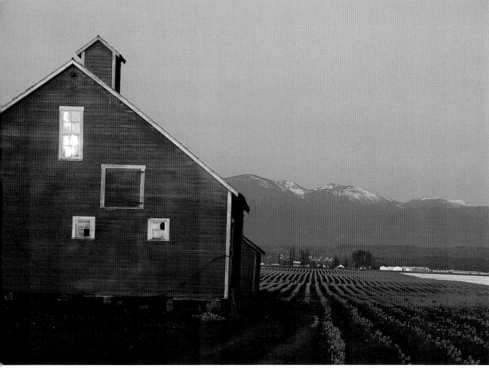

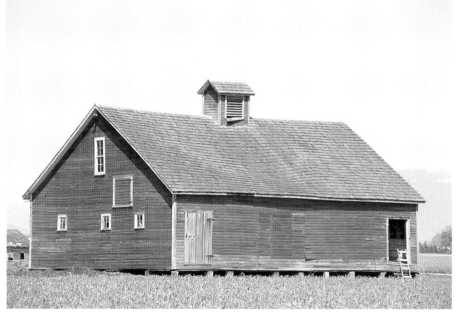

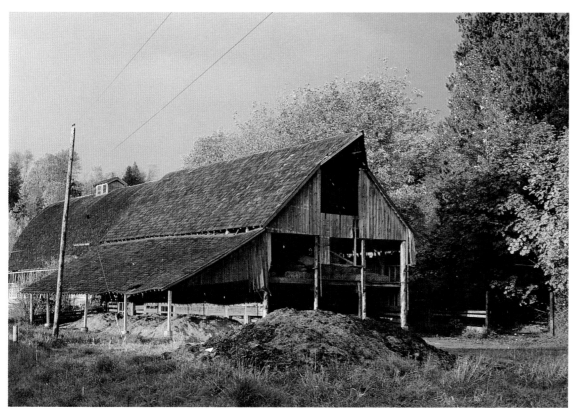

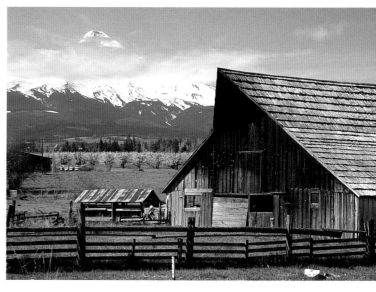

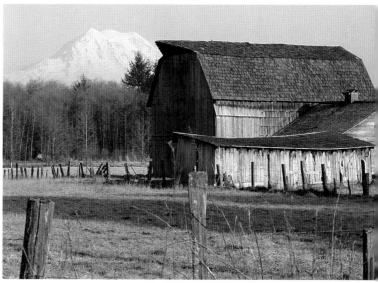

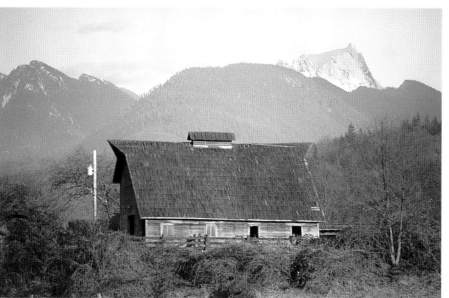

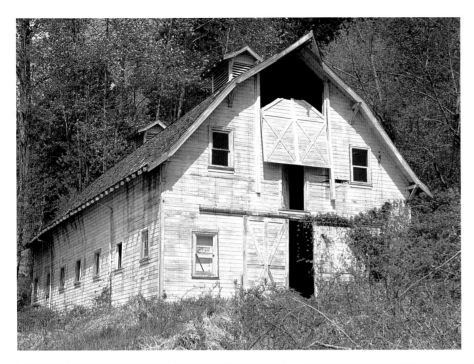

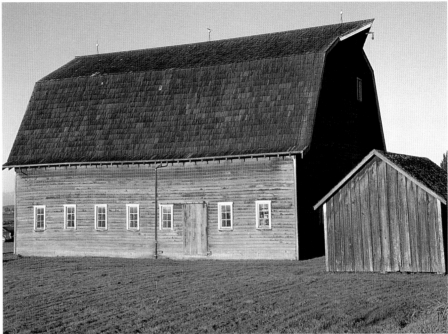

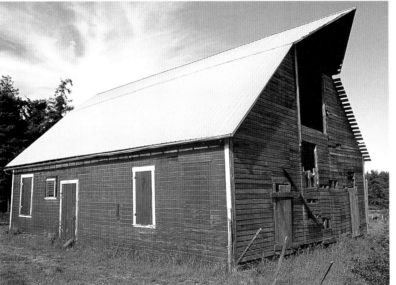

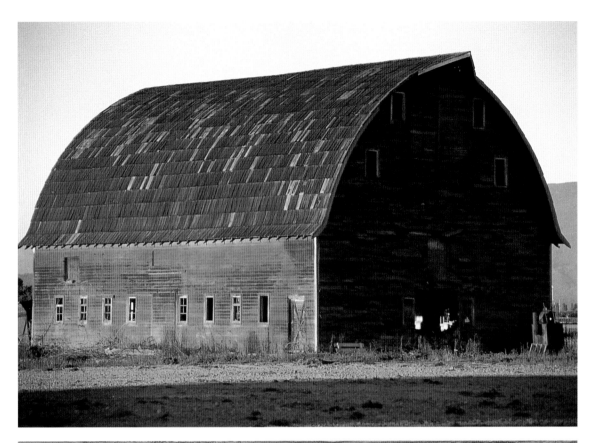

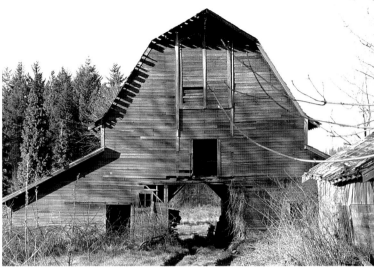

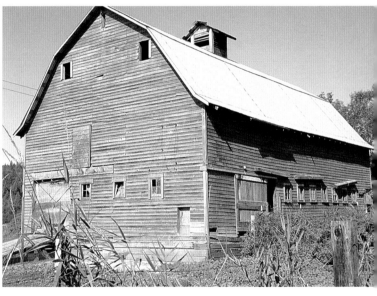

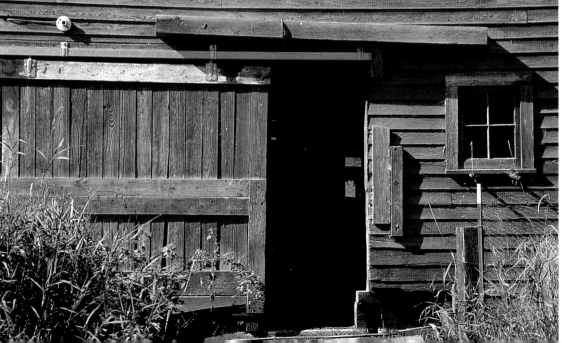

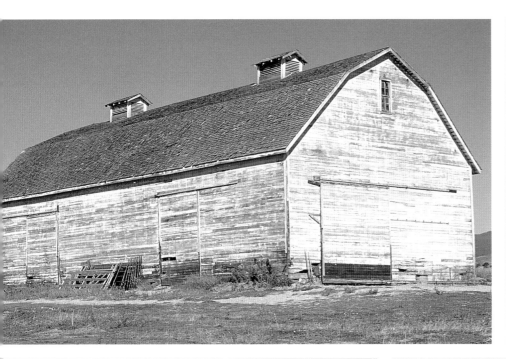

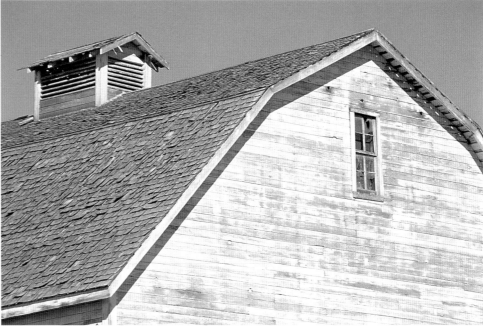

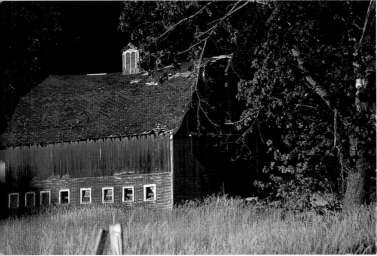

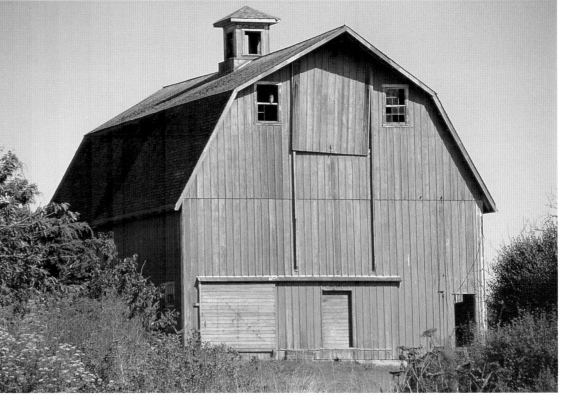

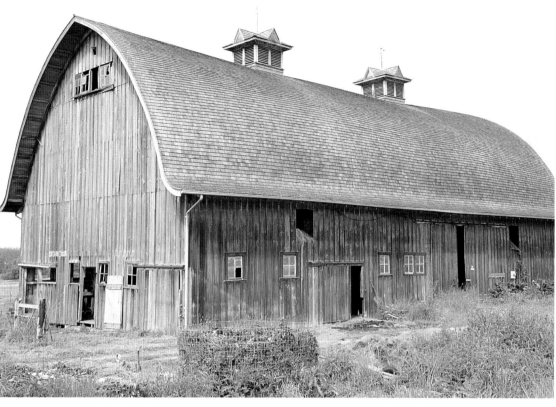

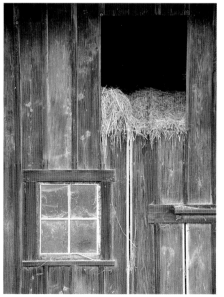

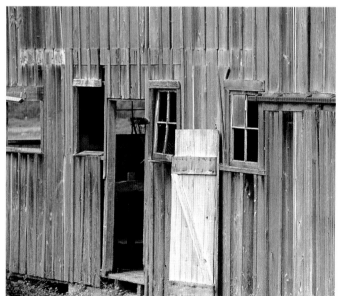

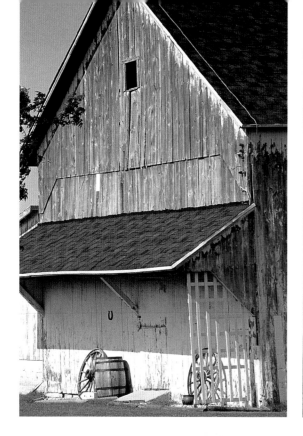

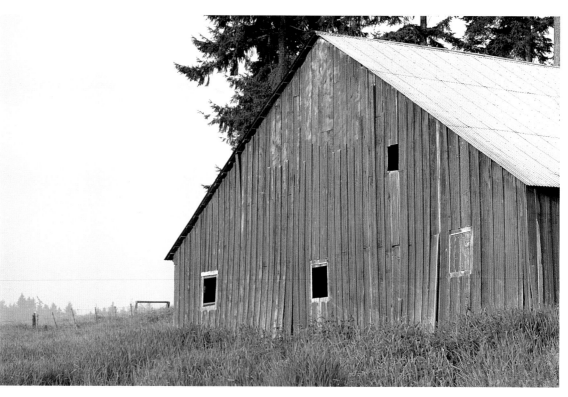

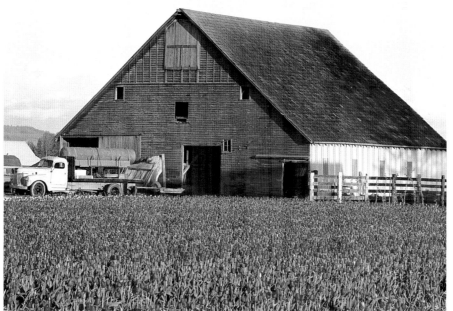

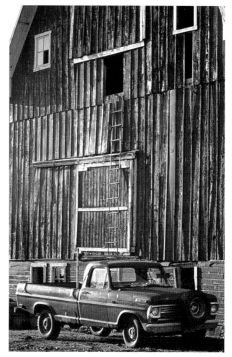

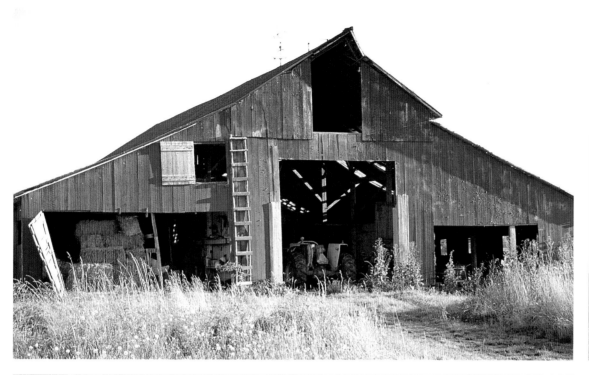

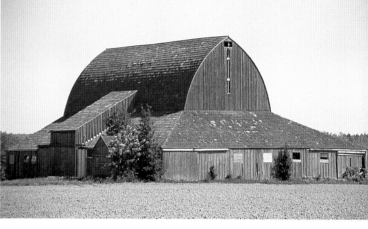

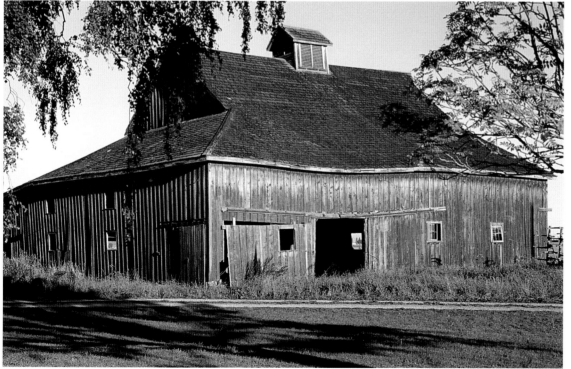

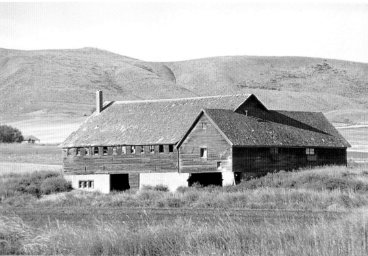

Silos

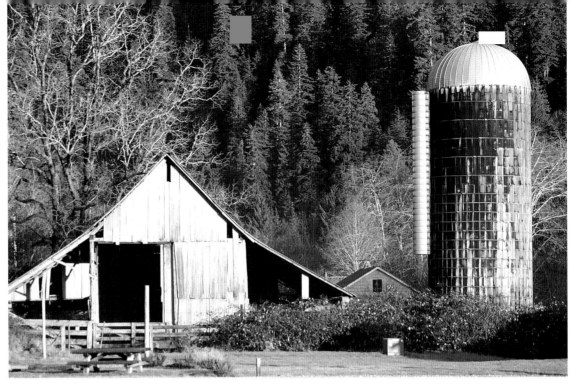

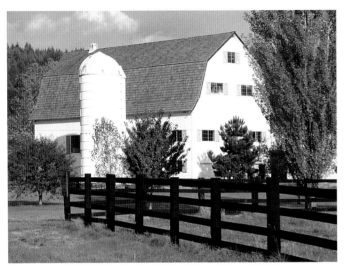

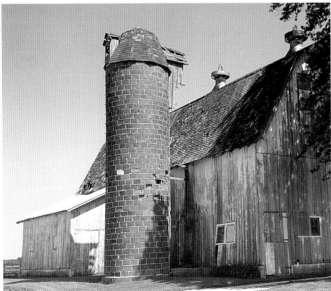

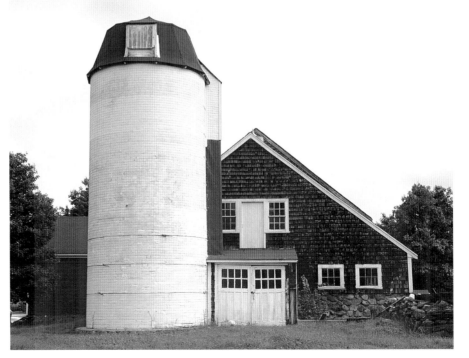

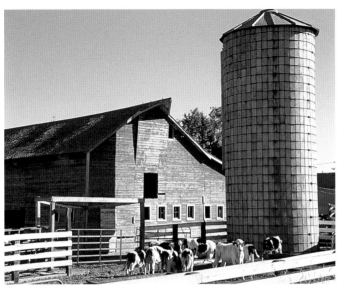

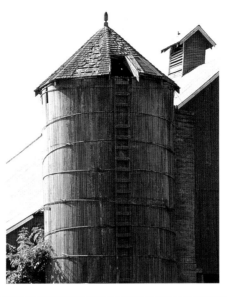

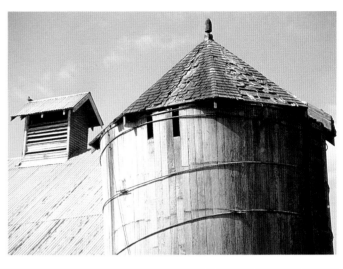

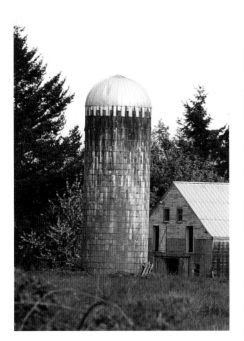

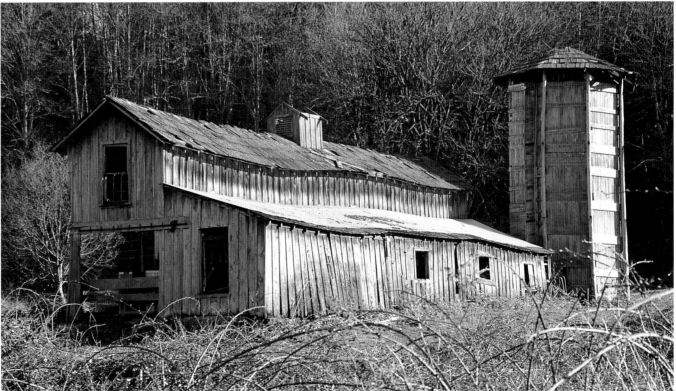

Bygone Dreams in Oil

Materials

Brushes

Nos. 3 and 6 round brushes (soft hair)

⅛-inch (3mm), ½-inch (12mm) and 1-inch (25mm) flat brushes (soft hair)

Other

18" x 24" (46cm x 61cm) Fredric Medium-Texture Duck Canvas

Natural sea sponge (with many little fingers sticking straight out)

Palette (paper, glass or enamel tray)

Palette mixing knives

Terry towel and/or paper towels

Weber Odorless Turpenoid

Liquin

Krylon Kamar Varnish

Color Palette

Daniel Smith Original Oil Colors—
Burnt Umber, Cadmium Yellow Deep, Cadmium Yellow Medium, Cerulean Blue, French Ultramarine, Olive Green, Quinacridone Gold, Quinacridone Rose, Quinacridone Violet, Raw Sienna, Yellow Ochre

Rembrandt Oil Colors—Rembrandt Blue

Martin/F. Weber Co.—Permalba White

This unusual barn resided in Sequim, Washington, a picturesque town on the Olympic Peninsula. Several years, housing developments and strip malls later, this relic of the past is sadly no more. However, its memory lives on in this breathtaking painting by master artist Larry Weston.

The field of yellow flowers was shot at a suburban park in Kirkland, Washington, and the mid-level clouds were imported from Orcas Island, Washington.

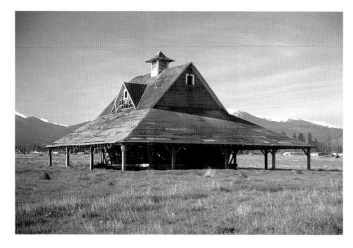

Reference photos

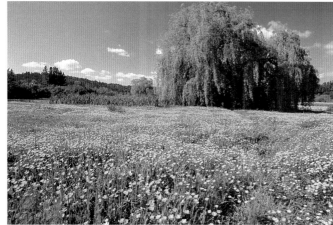

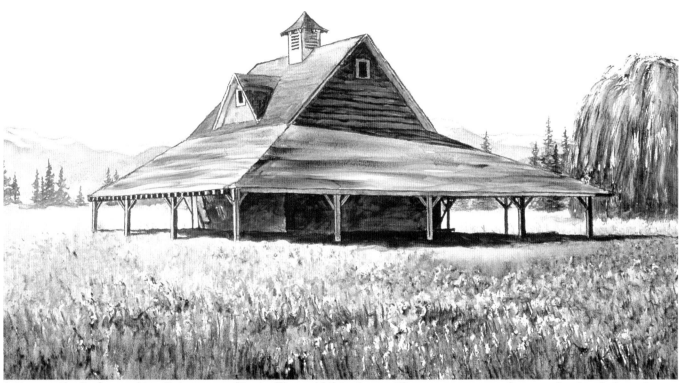

1. Prepare the Surface and Lay Out the Composition

First, select a prestretched and primed 18" x 24" (46cm x 61cm) medium-textured canvas. With a no. 3 round brush, establish the major lines of the barn. Graphite from pencils will lift off and muddy the initial colors of a painting, therefore use various thin mixtures of Burnt Umber and French Ultramarine, both mixed with several drops of Liquin. Then add thin glazes with a ½-inch (12mm) flat brush to give the barn its form and to lightly suggest the distant mountains and pine trees.

Create the grass texture using approximately 1" (25mm) square piece of natural sea sponge. Wet the sponge with water and squeeze out excess moisture. Next, dip the damp sponge into Turpenoid and then into your paint. Using short vertical strokes, lightly drag the sponge downward, using darker mixtures toward the bottom edge. Using the same sponge and technique, suggest a weeping willow tree on the right. (This same technique will be used to create the grass and willow tree in the final stage of the painting.)

For a mixing medium, use Turpenoid and Liquin. (Liquin is a drying agent, and its properties also make oil pigments very creamy.) Add two or three drops of Liquin and about a dozen drops of Turpenoid to your Permalba White pigment only. Mix thoroughly until soft mounds are created. White is usually added to most of your mixed colors, thereby transferring some of the mixing medium to any newly mixed colors. Only use additional Liquin when mixing colors where no white will be added.

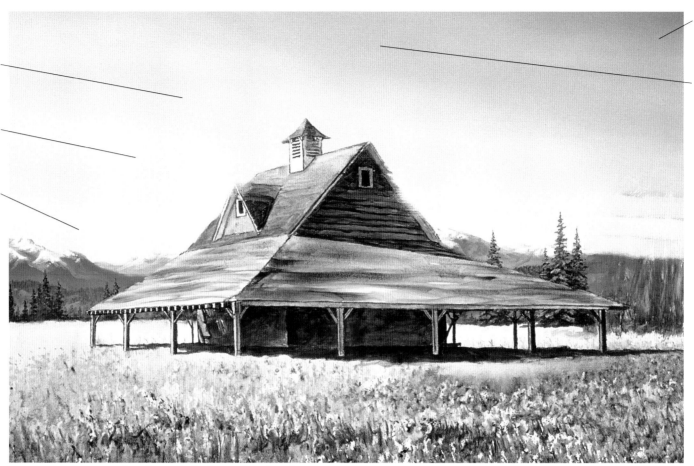

Band 3—Use Rembrandt Blue, Cerulean Blue and Permalba White.

Band 2—Use Rembrandt Blue and Permalba White to create a light powder blue.

Band 1—For the lowest part of the sky, use Permalba White with a touch of Quinacridone Rose.

Band 5—Use Cerulean Blue, French Ultramarine, Permalba White and a touch of Burnt Umber.

Band 4—Use Cerulean Blue with a little French Ultramarine and Permalba White.

2A. Paint the Sky

Start painting the sky using five bands of solid colors. The lightest part of the sky, just above the mountains, becomes progressively darker toward the upper-right corner. Using a 1-inch (25mm) flat brush, paint bands of color at a slight angle, making each band wider toward the left side, or toward the light source. Leave about a ¼" (6mm) of raw canvas between each band. After all of the bands are in place, crosshatch about 1" (3cm) between each band to merge the colors. Continue this procedure until all bands are locked together. Gently smooth out the crosshatched areas until a nice transition is achieved between each band. When blending, always work from darker mixtures into lighter ones to help retain the dark values. Once the basic sky is complete, allow it to dry before adding clouds. In the meantime, work on other parts of the painting.

2B. Add the Mountains and Trees

Darken the darkest blue used in the sky using Cerulean Blue, French Ultramarine and Burnt Umber. With a ½-inch (12mm) flat brush, block in the mountains, except for the snow on top.

For the snow, use Permalba White with a trace of Cerulean Blue. Using a no. 6 round brush, block in the snow without touching the blue. Once completed, use light crosshatching to merge the two colors together.

Use the leftover colors from the sky to suggest some contour within the mountains to break up any flatness.

To paint the large distant trees at the base of the mountain, use nos. 3 and 6 round brushes and mixtures of Olive Green, French Ultramarine and a touch of Burnt Umber. Use quick, little horizontal strokes at the top of the trees. Make the strokes wider with a slight downward motion as you move toward the base of each tree. Add a few highlights on the left side of each tree.

Helpful Hint

Try painting everything darker than it will appear in the final painting. In oils, it is much easier to lighten a dark color than it is to try and darken a light color.

3. Paint the Clouds, Grass and Weeping Willow

Before actually painting the clouds, all of the colors needed are premixed into the hues (colors) listed below.

Mixing Colors for Step Three

Medium blue gray = Permalba White + Cerulean Blue + Quinacridone Rose + Burnt Umber (just a little)

Light blue violet = Permalba White + Cerulean Blue + Quinacridone Rose

Medium pink violet = Permalba White + Quinacridone Rose + Cerulean Blue

Light pink violet = Permalba White + Quinacridone Rose + Cerulean Blue

Very light pink = Permalba White + Quinacridone Rose

4. Underpaint the Barn

Paint the entire barn with flat planes of color using three basic values. For the darkest area (under the barn's roof), use a mixture of Burnt Umber, French Ultramarine and Quinacridone Rose. For the middle values (the roofs and side posts in shadow), use the same colors with a little Permalba White. For the lightest areas where the sun hits directly on the barn, use combinations of Raw Sienna, Cadmium Yellow Medium, Quinacridone Gold and Permalba White.

Once the blocking-in process is completed, add more interest to the flat areas by adding minor color and value changes. Use a ½-inch (12mm) flat brush for the larger areas and nos. 3 and 6 round brushes for the smaller ones.

Clouds—Work from dark to light. Using a ½-inch (12mm) flat brush, establish basic shapes by roughing in the billowing effects, then further refine using a no. 6 round. Once dry, add the highlights. The edges of the clouds are not the lightest areas; generally the center of the billows are where the lightest values appear.

Weeping Willow—With the same dark colors used for the grass, create the tree's basic shape using a piece of natural sea sponge. Then sponge on lighter colors, being careful not to cover all of the darker colors. Apply the lightest green and texture with a no. 3 round brush. (Clumps of foliage in the center of the tree are generally the lightest.)

Grass—Paint the distant area using Yellow Ochre and a little Permalba White with a ½-inch (12mm) flat brush. Suggest distance and contour with a grayed-down light green (Yellow Ochre and Cerulean Blue). Use more intense greens down to just below the barn. Suggest dirt near the barn using Raw Sienna and Permalba White. With a 1-inch (25mm) flat brush, underglaze the lower portion of the field, using darker green toward the lower edge of the canvas. Starting just below the barn, paint the grass using the natural sea sponge. While the grass under glaze is still wet, add texture and lighter values. With a no. 3 round brush, paint a few brushstrokes along the bottom edge to simulate individual grassy stalks. About 80 percent of this green field will be covered with flowers, so only a few stalks are needed. Allow to completely dry. (All of the greens used in the field are mixtures of Olive Green, French Ultramarine and Burnt Umber. Quinacridone Rose was added to gray down some of the mixtures while Cadmium Yellow Medium and Permalba White were used to enrich and lighten some of them.)

Sponging Hint
Keep the sponging colors thin to avoid little peaks of stiff pigment rising from the surface of the canvas.

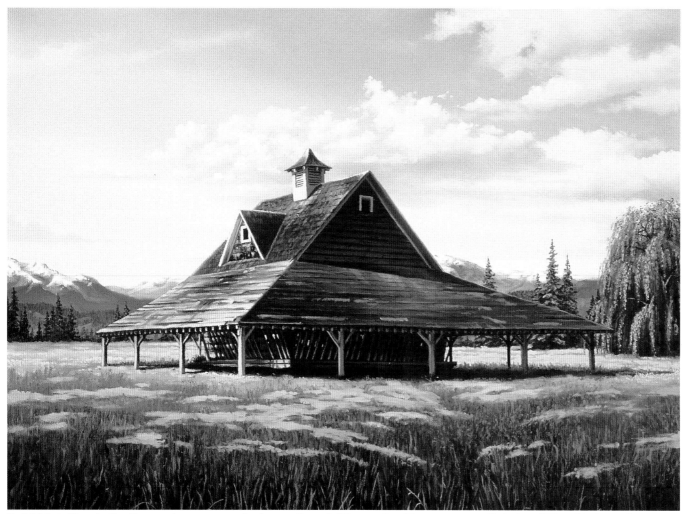

5. Add Detailing to the Barn and Underpaint the Flowers

Add the details in the darkest areas first. Suggest minor objects, such as the vertical boards, by using grayed-down blues (French Ultramarine mixed with Burnt Umber and a touch of Permalba White).

For those highlighted areas of the roof that appear white, use Permalba White with a trace of Cadmium Yellow Medium and Quinacridone Rose. In the shade, use French Ultramarine, Burnt Umber and less Permalba White for the cool white areas.

For the detail and texture of the roof, use cool colors lightly brushed onto the darker areas. Use combinations of French Ultramarine, Burnt Umber, Raw Sienna and Permalba White. Use an ⅛-inch (3mm) flat brush to suggest wood shingles on the upper roof and the boards on the lower left. Use Raw Sienna, Cadmium Yellow Medium, Quinacridone Gold and Permalba White for the lighter, warmer values of the roofs. Apply value changes of no more than 15 percent on top of one another until the desired value is achieved. Use the same colors to delineate the warm sides of the posts that support the roof.

For the horizontal boards at the base, warm the previous mixtures by adding a little Raw Sienna. To suggest sunlight striking the boards, use mixtures of Raw Sienna, Quinacridone Gold and Permalba White.

Suggest distant flower clusters with light mixtures of Cadmium Yellow Medium and Permalba White. Use Quinacridone Violet to gray down the intensity of distant yellows. Use stronger yellows for the middle-ground flowers, adding Cadmium Yellow Deep here and there. Allow to dry until tacky.

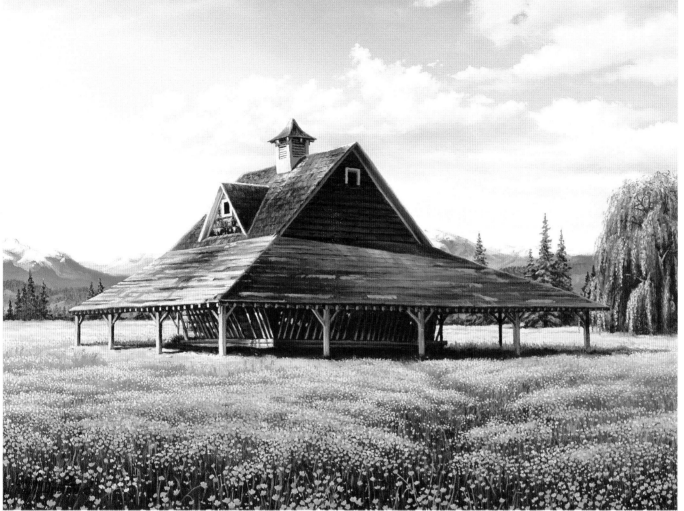

Bygone Dreams

LARRY WESTON

18" x 24" (46cm x 61cm)

6. Finish the Flowers and Add a Final Protective Coat

Use the same colors in the previous step to complete the field of flowers, painting the foreground flowers in a low key, while using the richest yellows for the middle ground. As the flowers recede within the painting, make the yellows lighter and slightly cooler.

Only the flowers in the immediate foreground need to be the shape of the variety being portrayed. After painting the foreground flowers, add the rest of the flowers using random dots made with the tip of a round brush. Group some dots into clusters while leaving others to stand alone. Place the darker as well as the lighter dots over the original brushed-on yellow patterns. Make the dots progressively smaller as the flowers recede.

After your painting is finished and completely dry, brush pure Liquin over the entire surface with a 1-inch (25mm) soft flat brush. This will bring life to those colors dulled from the painting process. After the Liquin is dry, use spray varnish for a protective coat.

Work outdoors on a warm, calm day and keep the painting lying flat on some newspaper. I highly recommend using eye protection and at least a dust mask. Start spraying from the direction that your painting will be viewed. Using a horizontal motion, start at the top and rapidly work down to the bottom, spray-ing right off the edges of the canvas. Allow the varnish to dry between coats, usually about five minutes. Then rotate the canvas by one-quarter turn and spray again horizontally top to bottom. Keep rotating the canvas and spraying until you have sprayed from all four sides. Spray the fifth and final coat from the direction that you would view the painting. This will seal all raised surfaces of the painting and provide a nice matte finish.

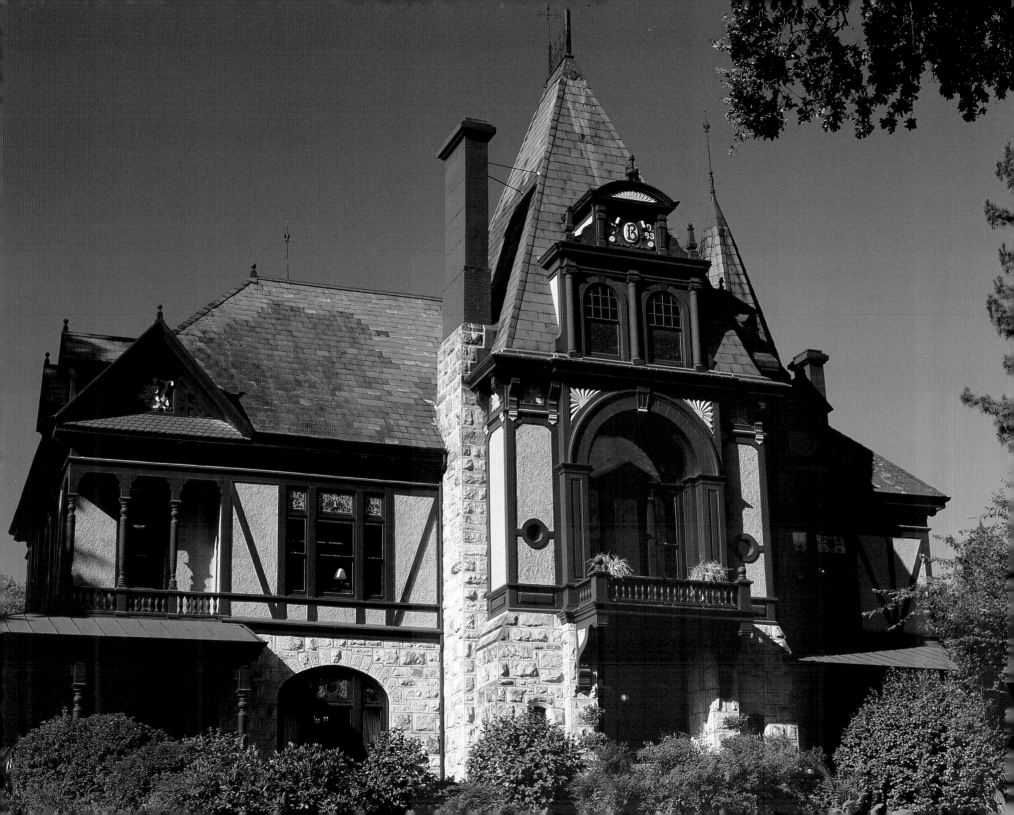

TWO
Houses

A large portion of the houses pictured in this section are Victorian because of their popularity as subjects, but you'll also find an eclectic collection of everything from Tudors to Southwestern and late twentieth century-style dwellings, and more.

Tudor

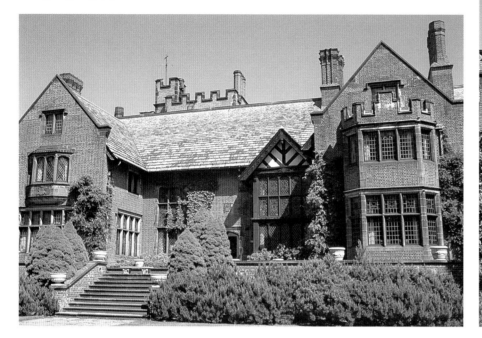
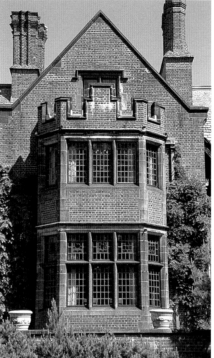
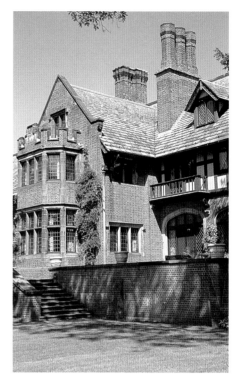
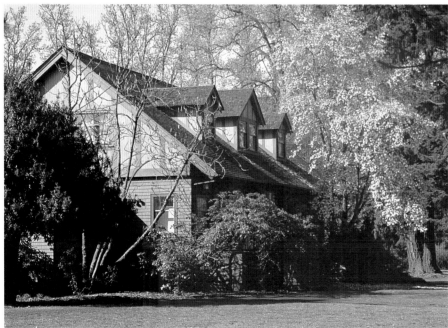
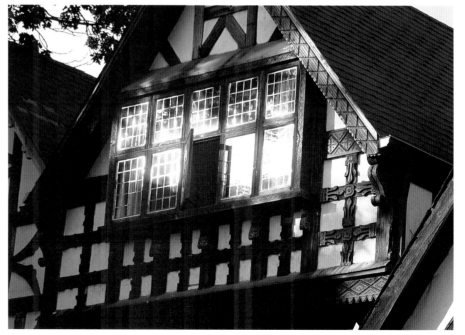

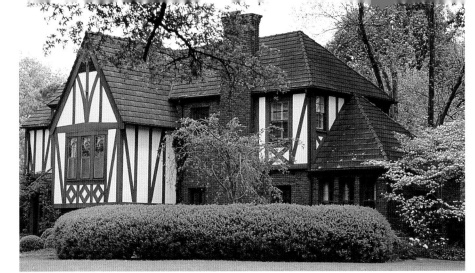

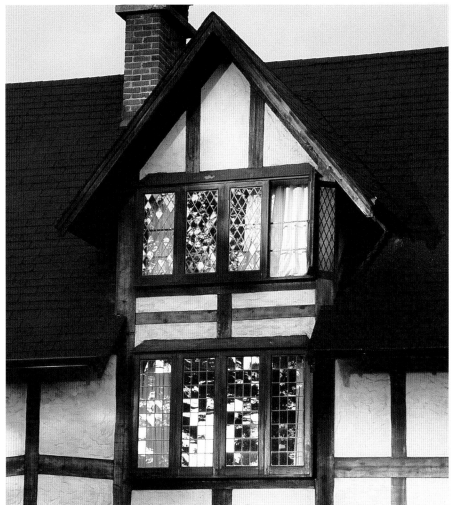

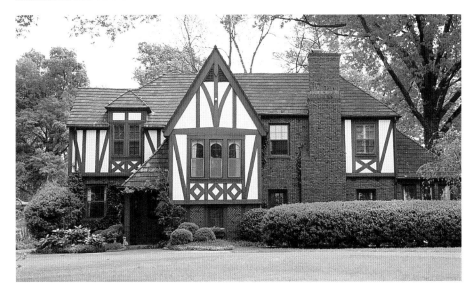

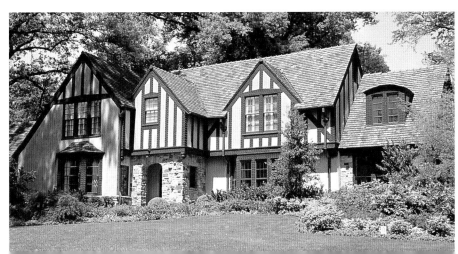

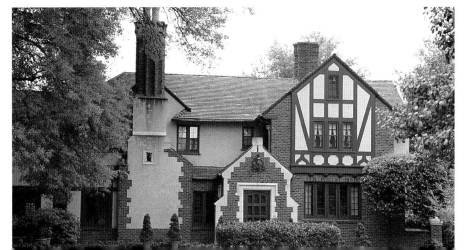

Victorian

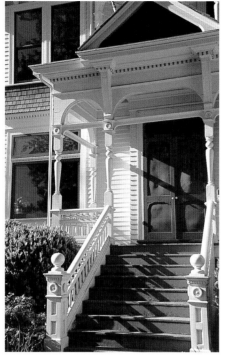

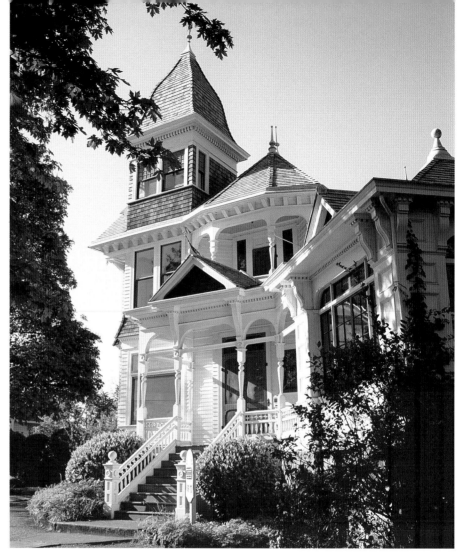

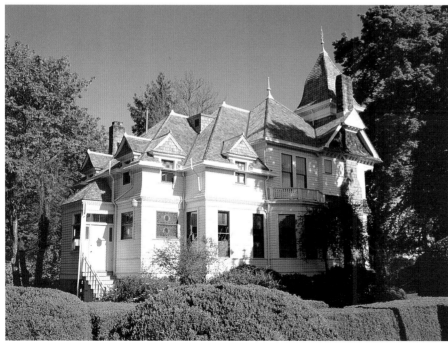

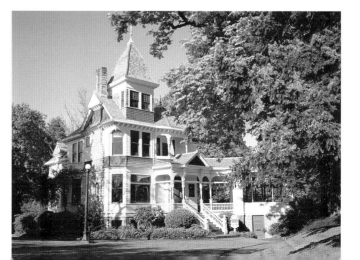

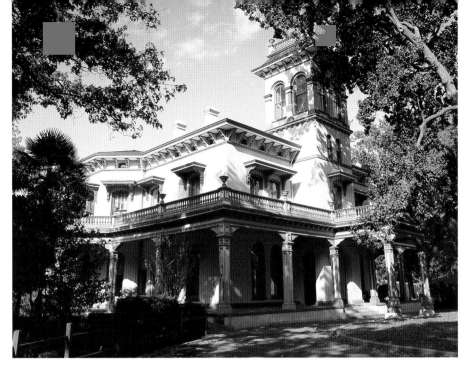
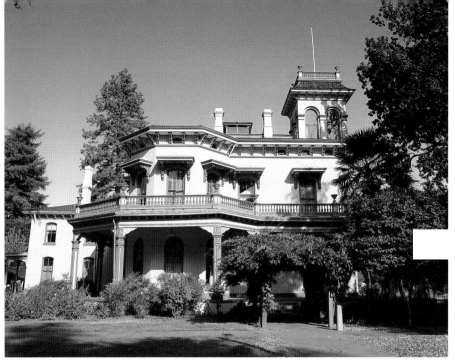
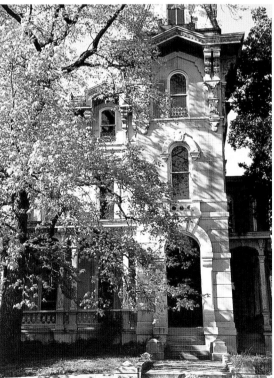
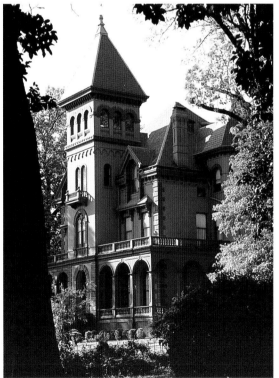
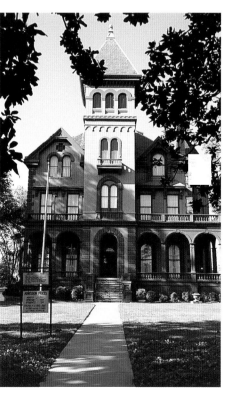

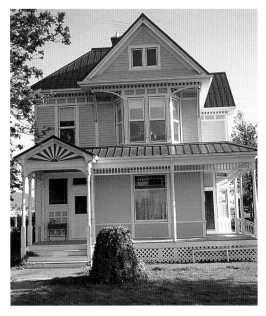
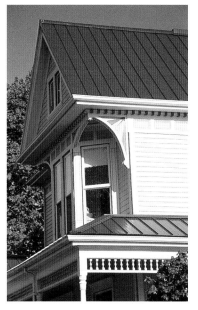
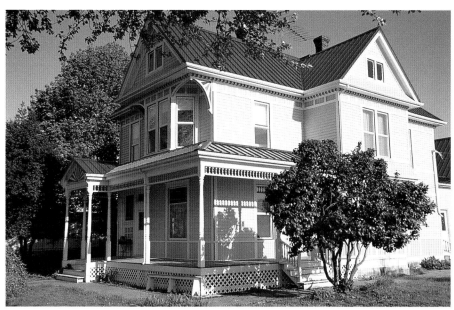
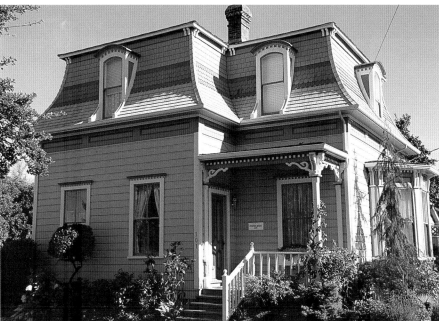
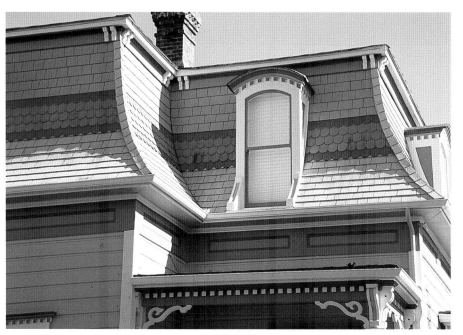

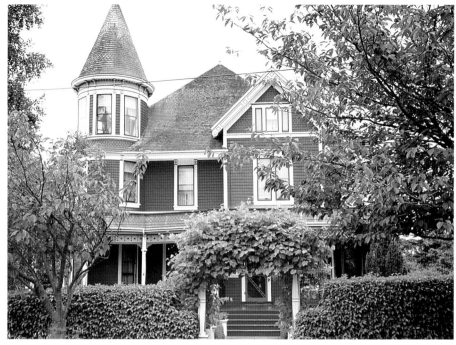

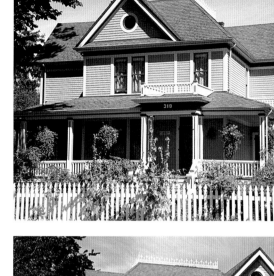

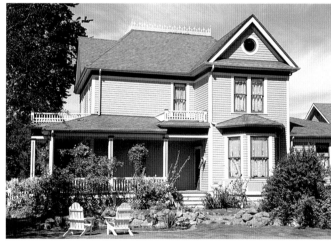

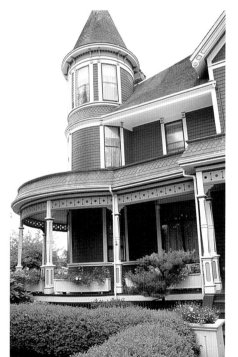

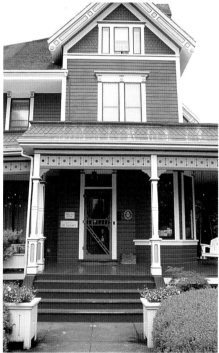

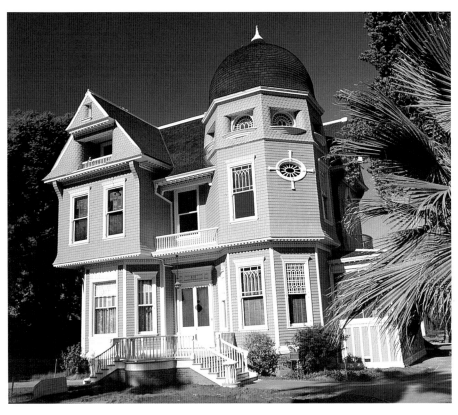

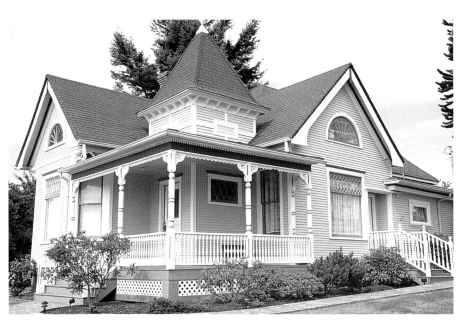

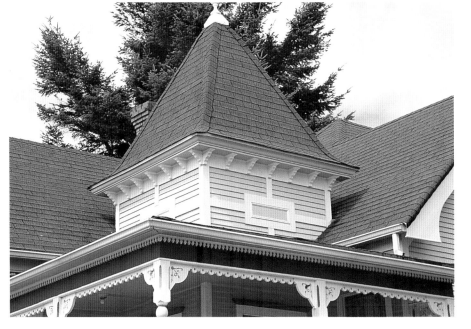

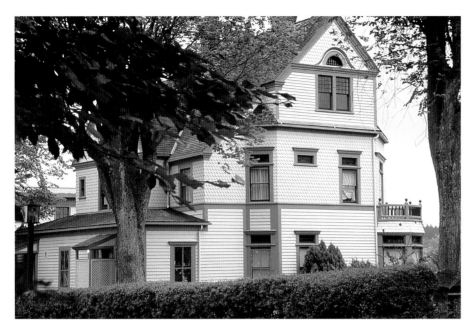

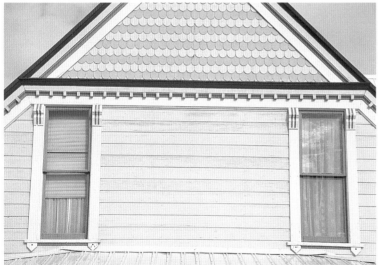
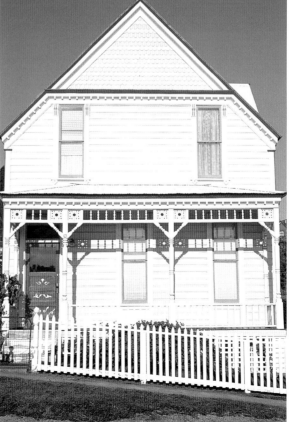

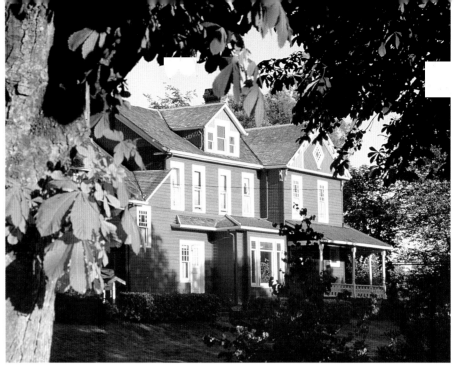

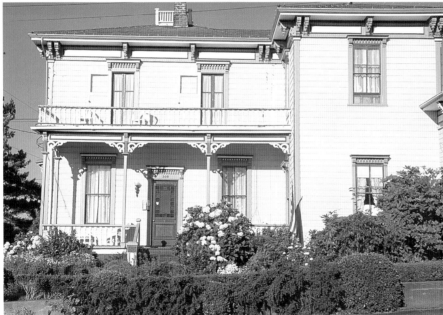

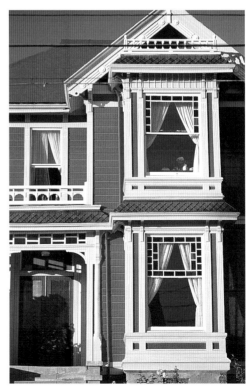

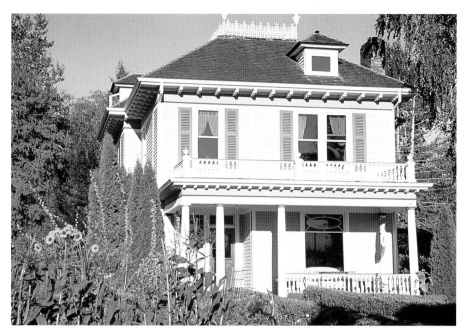

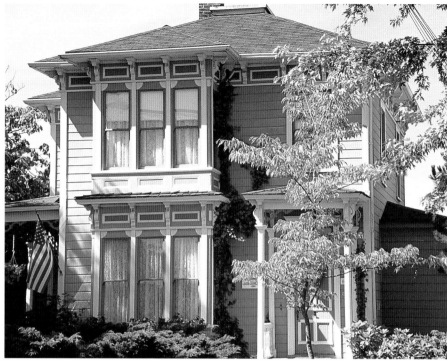

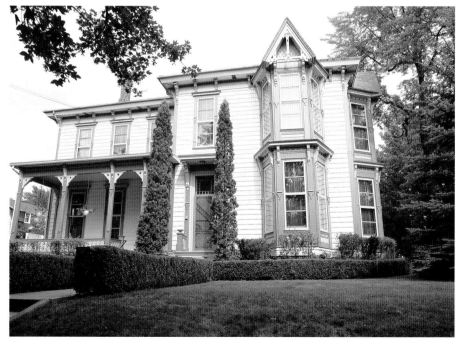

Classical Revival

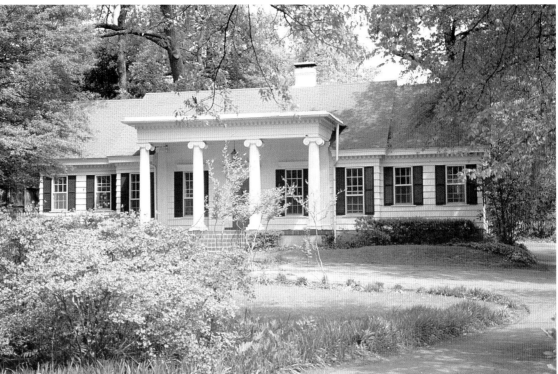

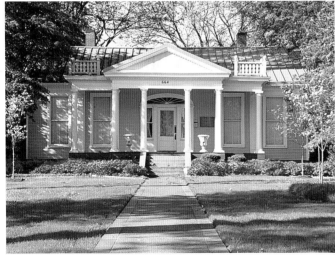

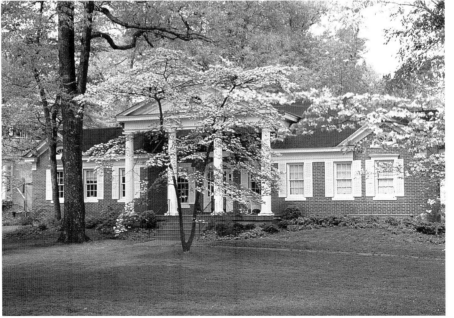

Early American

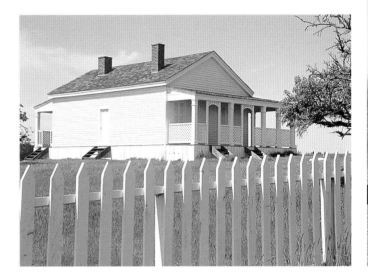

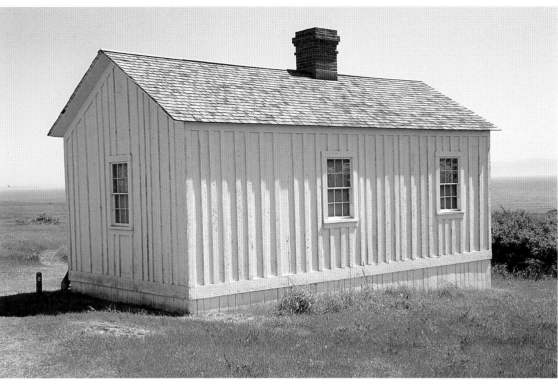

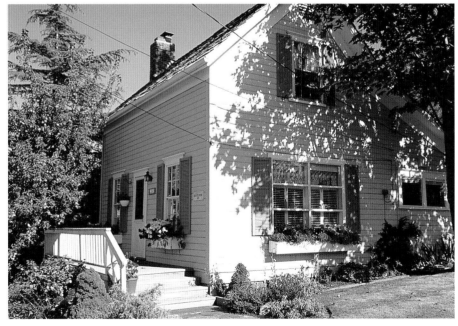

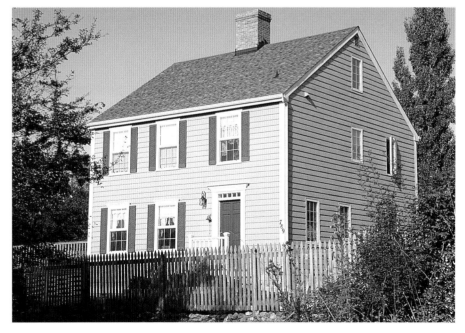

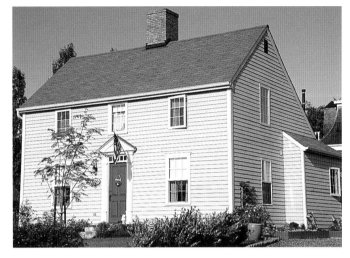

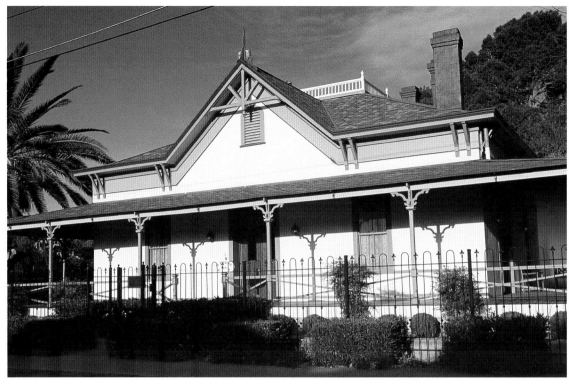

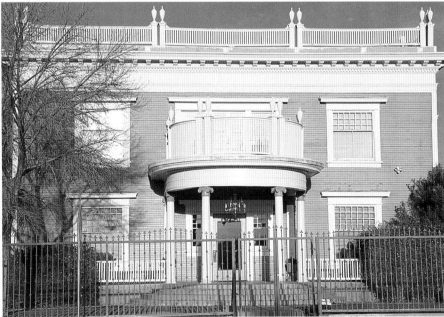

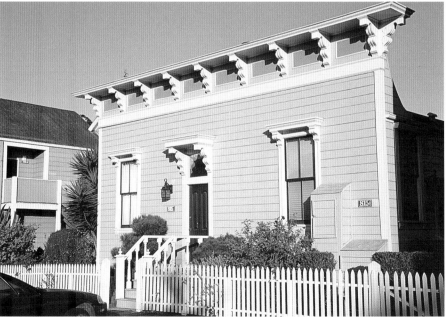

Southwestern

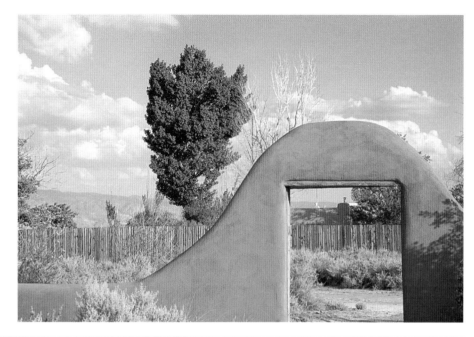

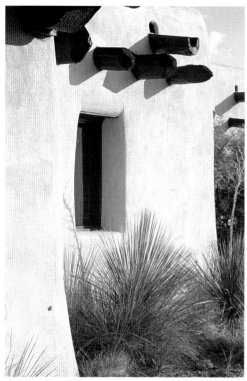

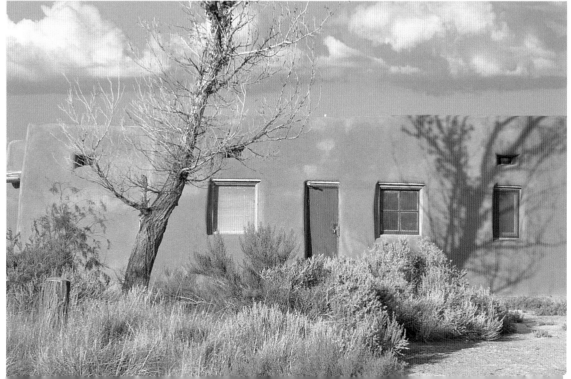

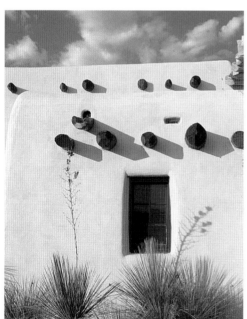

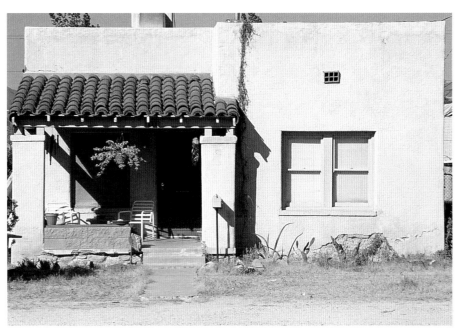

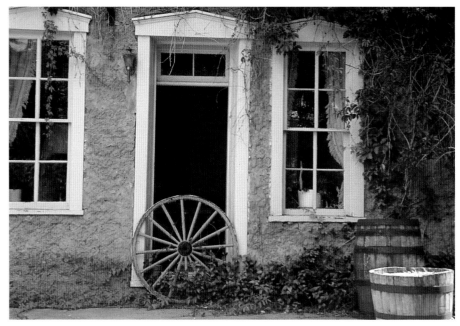

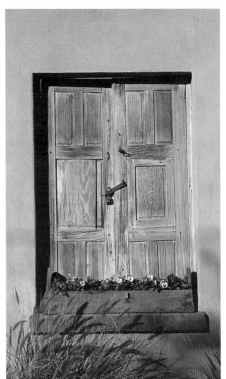

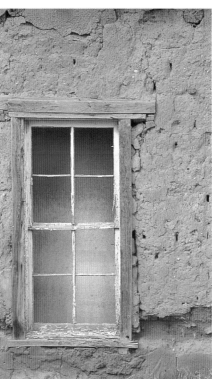

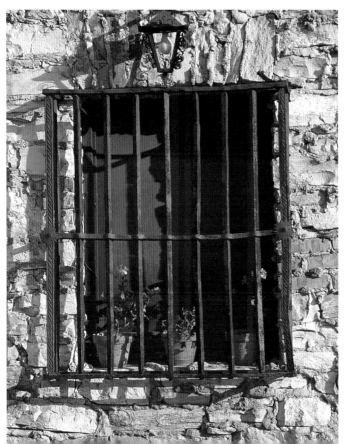

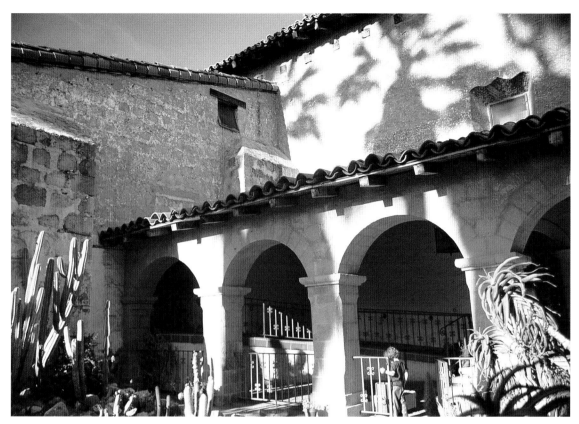
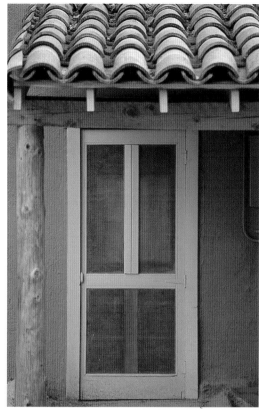
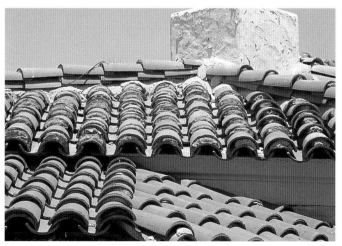
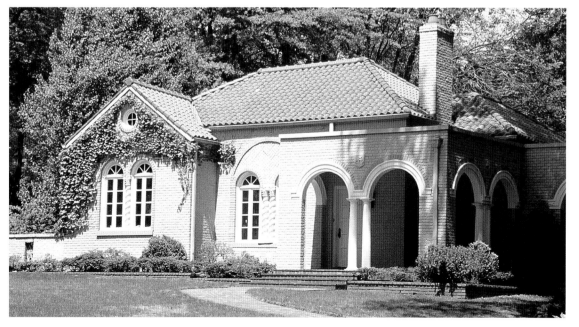

Country

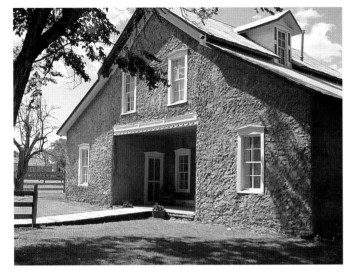

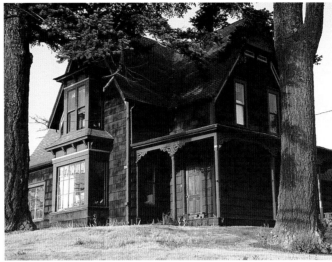

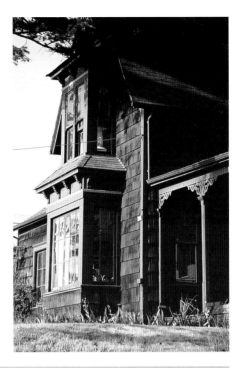

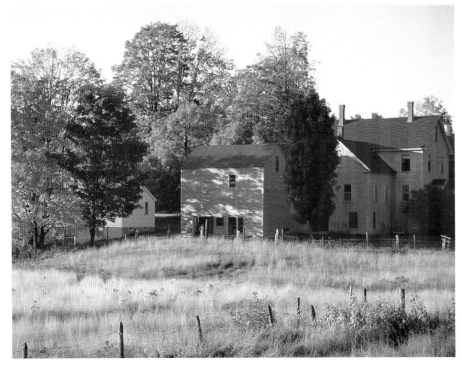

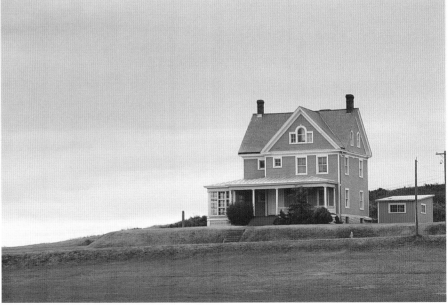

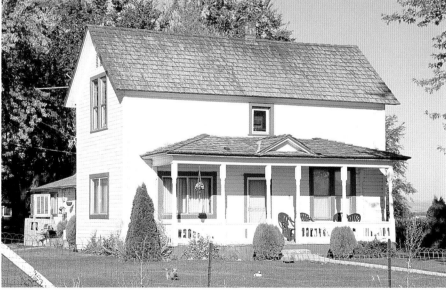

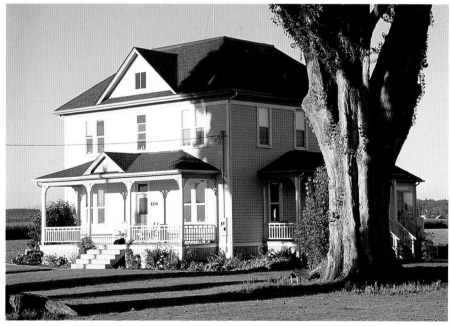

Late 20th Century

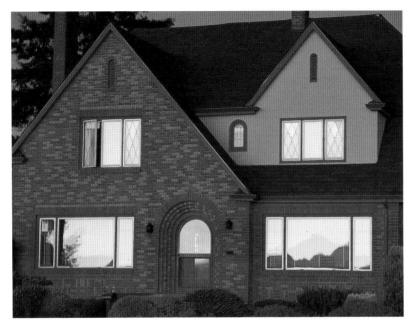

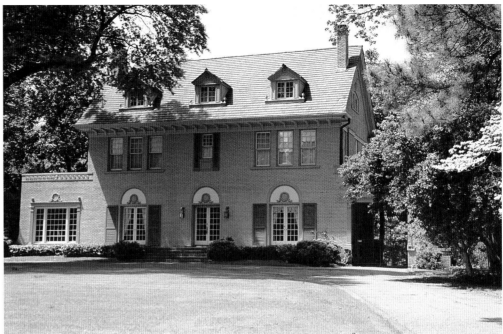

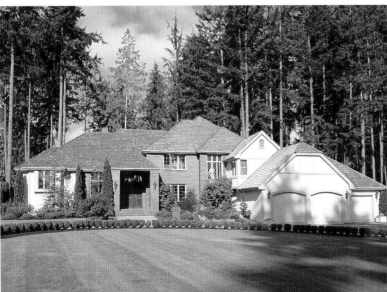

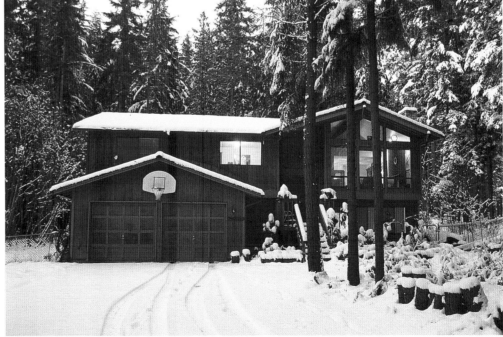

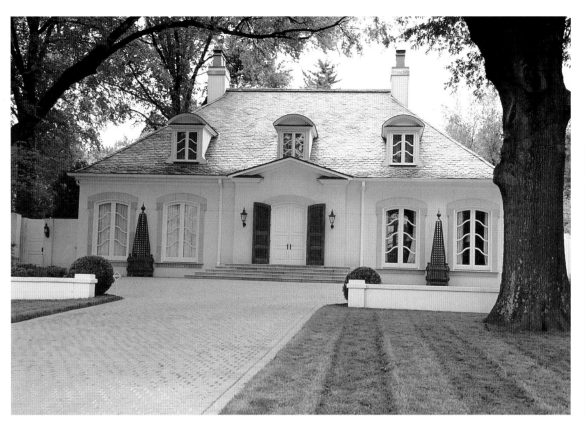

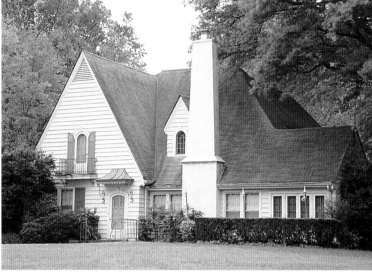

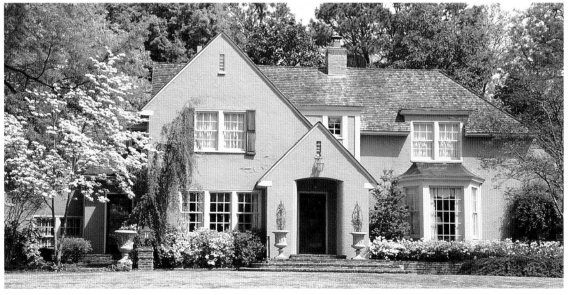

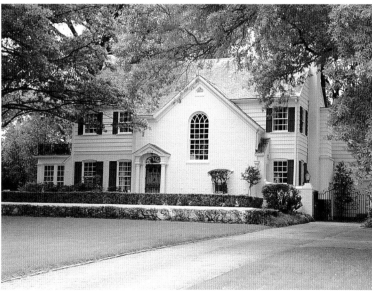

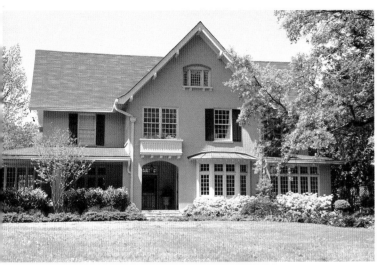

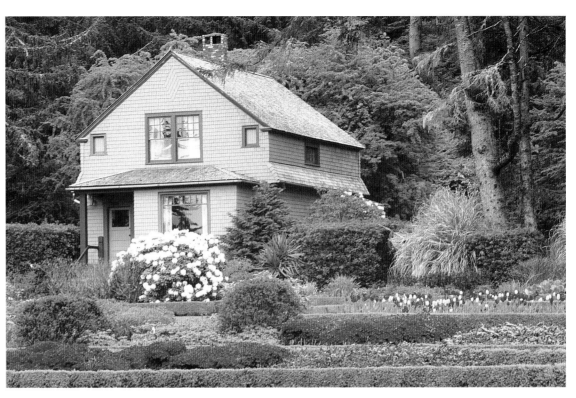

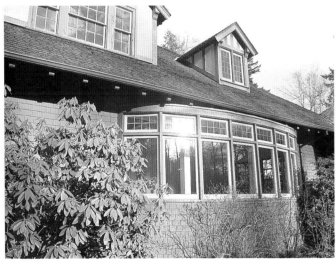

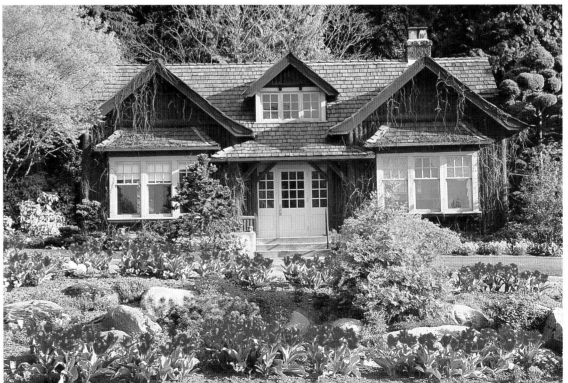

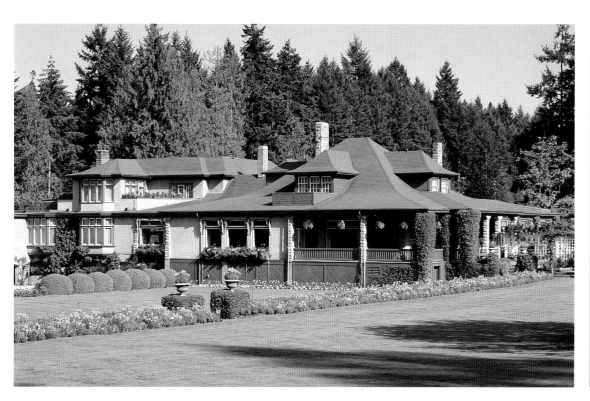

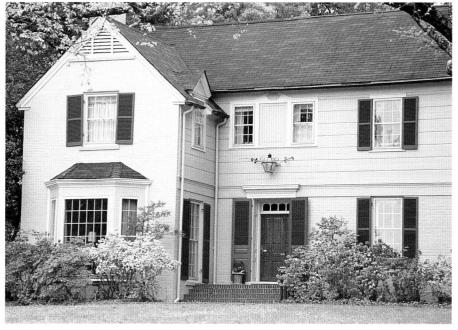

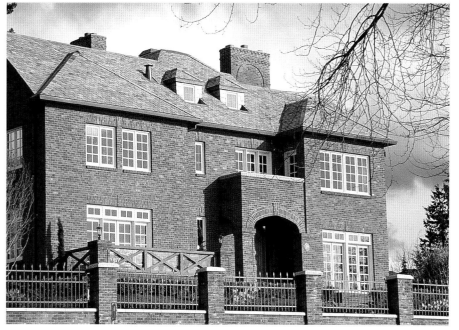

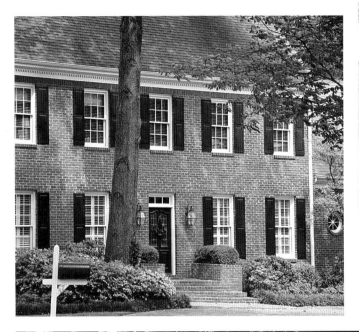

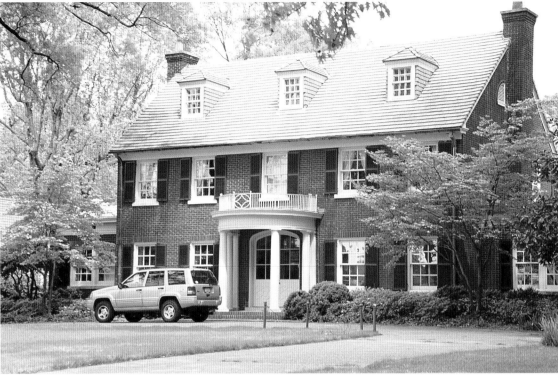

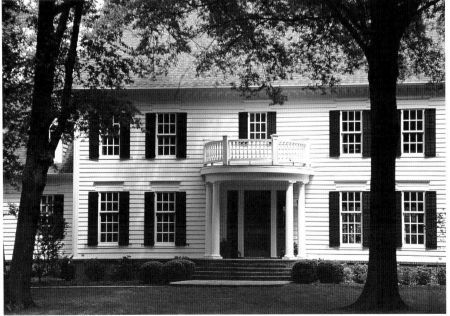

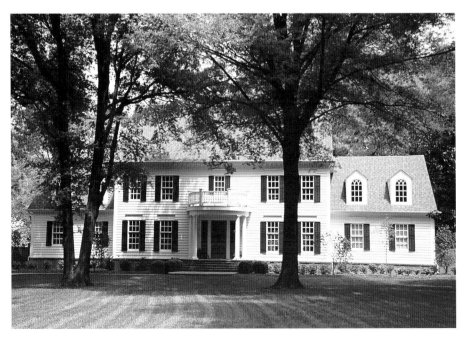

South Shore Acres in Pastel

by Frank E. Zuccarelli, PSA

Brush

1" (25mm) white bristle oil brush (to brush off pastel for corrections)

Other

Acid-free foamcore board – 20" x 24" (51cm x 61cm)

Wallis sanded pastel paper – 14" x 18" (36cm x 46cm)

3M acid-free spray adhesive

HB graphite pencil

66B Rexel Derwent pastel pencil

Krylon Workable Fixatif

Kneaded eraser

Soft white tissues (to clean pastel sticks)

Color Palette

Nupastels—Bottle Green–298-P, Cold Light Gray–299, Warm Light Gray–239-P, Cordovan–353-P, Dark Green–278-P, Deep Cadmium Yellow–257-P, Deep Chrome Yellow–207-P, Ivory–277-P, Lemon Yellow–217-P, Light Turquoise Blue–245-P, Raw Sienna–233-P, Sap Green–208-P, Titan Brown–333-P

Sennelier Pastels—Cadmium Red, Cadmium Yellow Medium, Cobalt Blue, Light Yellow Green, Lilac, Medium Dark Ultramarine Blue, Pale Yellow Medium, Raw Sienna, Very Light Blue

This scene was photographed in the lush Skagit Valley, about sixty-five miles north of Seattle, Washington. On the first three weeks of every April, the area becomes a riot of color with hundreds of acres of tulips, and is sprinkled with quaint barns and surrounded on three sides by snow-capped peaks.

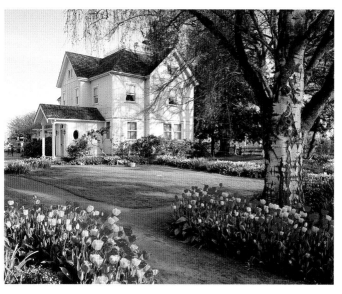

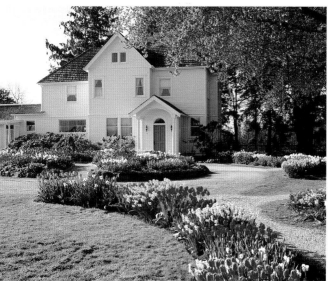

Reference photos

1. Prepare the Surface and Lay Out the Composition

On foamcore board, measure a 3" (8cm) border with a HB graphite pencil. Thoroughly spray the back of the sanded pastel paper with spray adhesive. Carefully place and adhere the pastel paper to the border of the foamcore board.

Next, using an HB graphite pencil, indicate the layout, paying close attention to proportions and relationships. Darken the lines slightly with the Derwent pastel pencil.

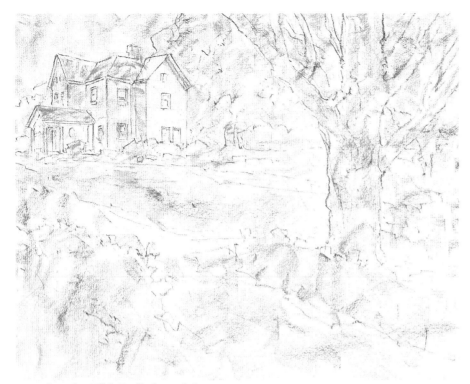

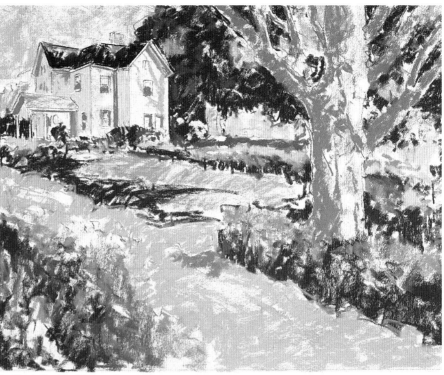

2. Underpaint With Preliminary Colors

Lightly underpaint with Nupastels. Apply Sap Green loosely in the grassy area and foliage. Apply Warm Light Gray to the sky and shadow side of the house. Add Titan Brown to the roof and tree trunk in the foreground.

3. Block In the Elements

Sketch in the darks of distant trees, the shadow on the grassy area and foreground growth with Bottle Green. Apply Light Turquoise Blue to the sky and sky holes seen through the dark trees. Apply Warm Light Gray to the mass in the foreground pathway and shadow side of the large tree trunk. Add an irregular patch of Deep Cadmium Yellow beneath the shape of the dark tree, in the middle distance along the side of the house. Use Sap Green to indicate light streaming across the grass. Place yellow flowers in the foreground with Deep Chrome Yellow. Apply a light spray of fixative to the entire painting.

4. Layer and Glaze to Finish

Complete the unshadowed parts of the house with Ivory. Use Cold Light Gray for the shadows of the house. Apply Raw Sienna (Nupastel) to the pathway, touching up with Sennelier Raw Sienna in some areas.

Touch up the tree trunk, limbs and the fence and roof with Cordovan. Lightly glaze with Medium Dark Ultramarine Blue over the pathway and foreground tree trunk and limbs. Apply Very Light Blue to the sky and glaze over the tree shadows on the side of the house.

Apply Cadmium Red and Lemon Yellow for flowers in the foreground and middle distance, then Cadmium Yellow Medium. Using pressure, apply Pale Yellow Medium last.

Use Dark Green to refine shadows on the grass and on the underside of the tree. Lightly apply Cobalt Blue to dark shadows on the grass. Apply a light glaze of Light Yellow Green across the lawn in the lightest areas.

Next, apply Warm Light Gray to the light side of the tree trunk. Lightly glaze Lilac on the pathway, sky, shadow side of the house and to the narrow path in middle distance, leading up to the house.

Take the painting outside and tap hard on solid surface to remove excess pastel dust. *Note:* Do not spray fixative on the finished painting unless all pastel dust has been removed either by tapping the back or using a small handheld vacuum held a few inches above the painting.

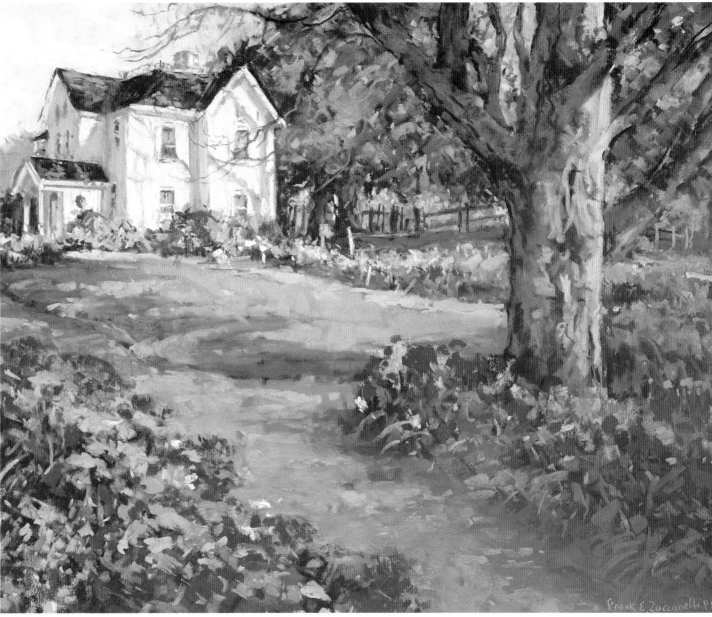

South Shore Acres

FRANK E. ZUCCARELLI, PSA

14" x 18" (36cm x 46cm)

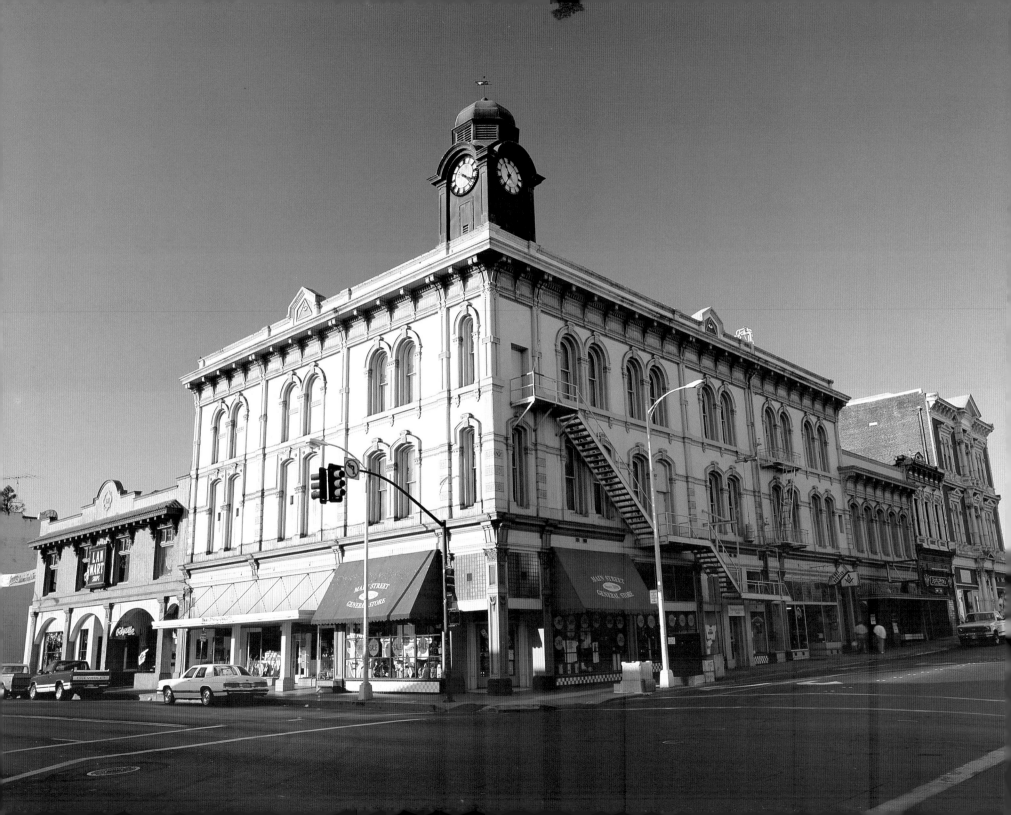

THREE

Buildings

In this section, you will find a variety of buildings and storefronts, both commercial and private, that will add interest to your paintings. Unusual, easily identifiable and big-city buildings, such as skyscrapers, have not been included because they would require a separate book to do them justice. Easily recognized structures have considerable reference material available and are usually of local interest only as art subjects.

1886

Storefronts

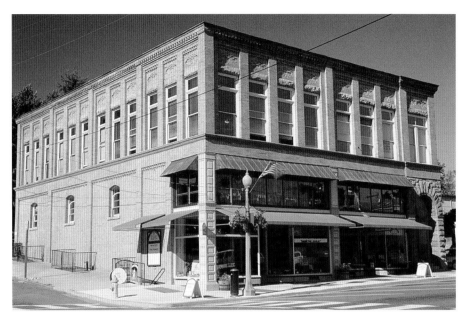

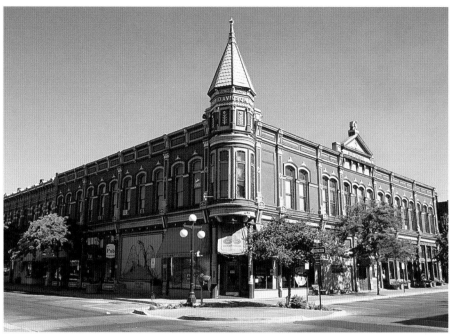

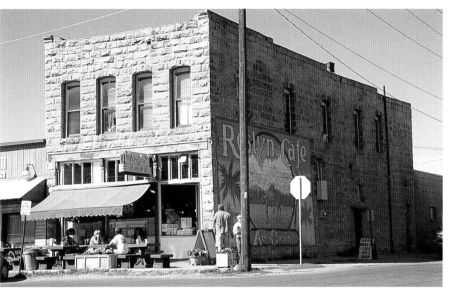

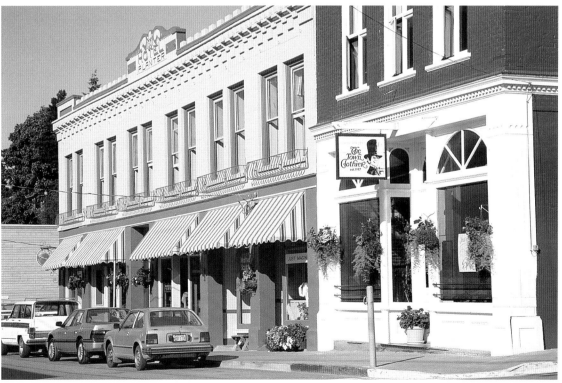

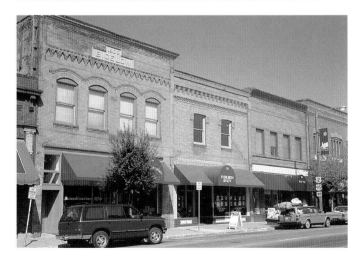

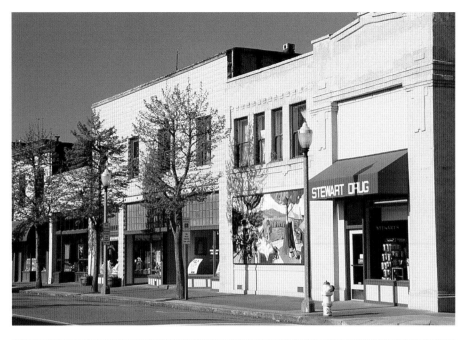

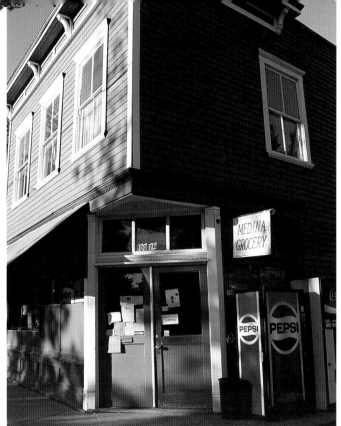

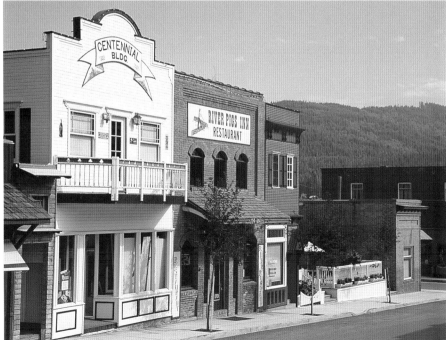

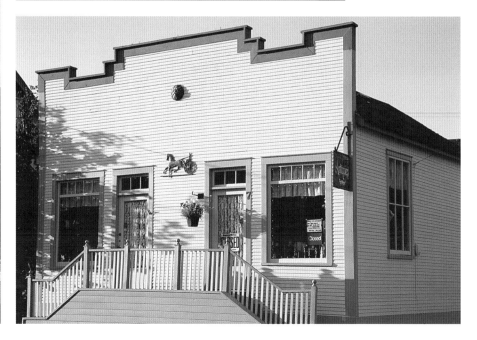

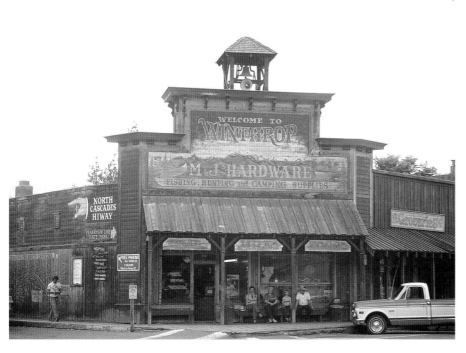

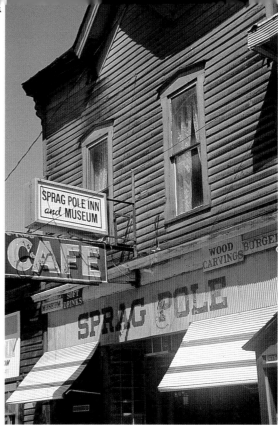

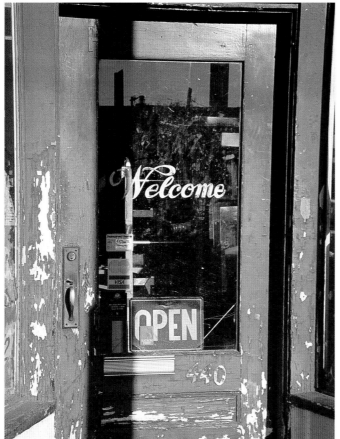

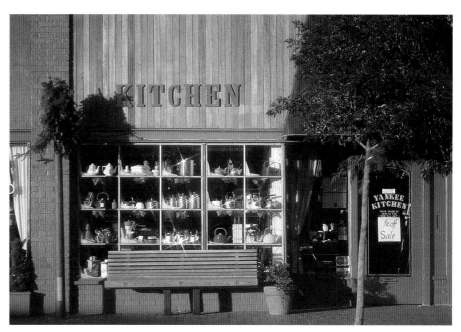

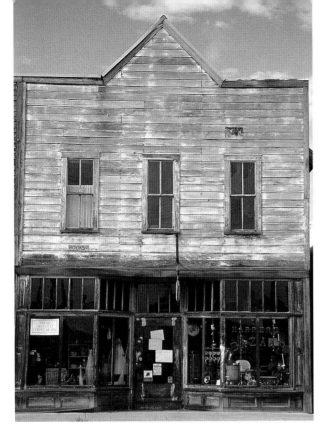

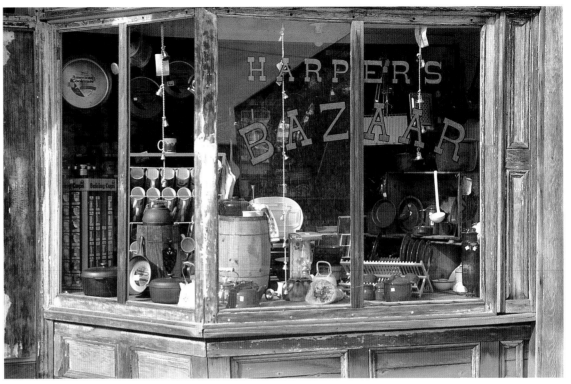

Mills

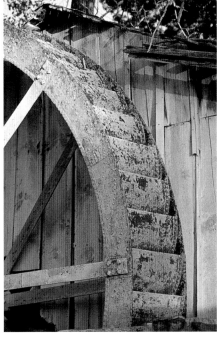

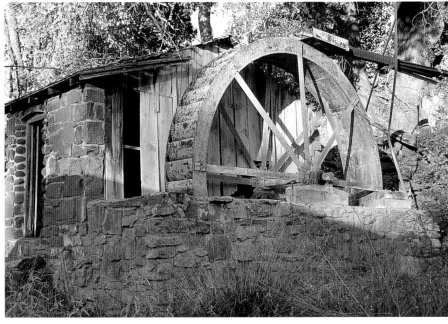

Shacks & Sheds

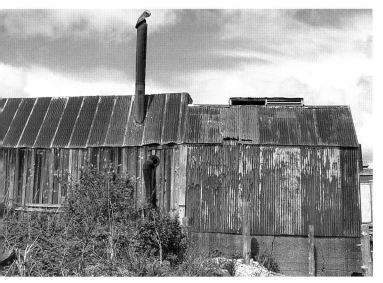

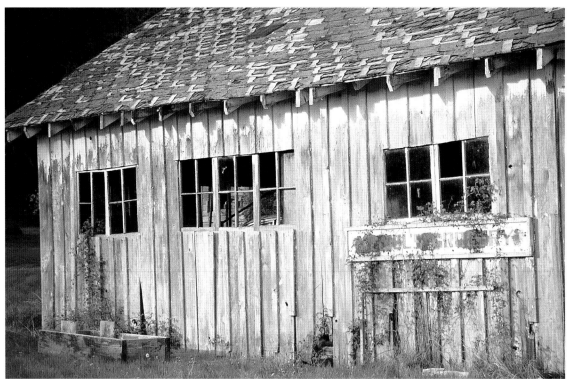

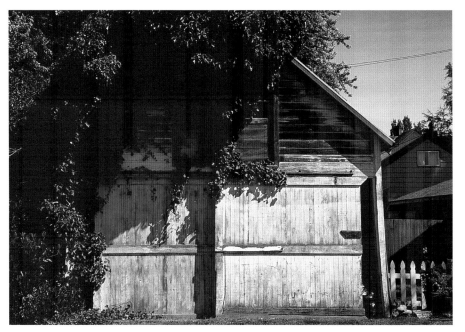

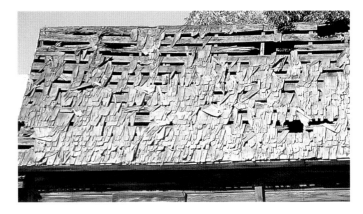
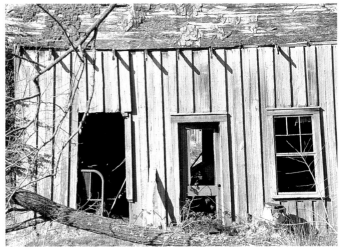
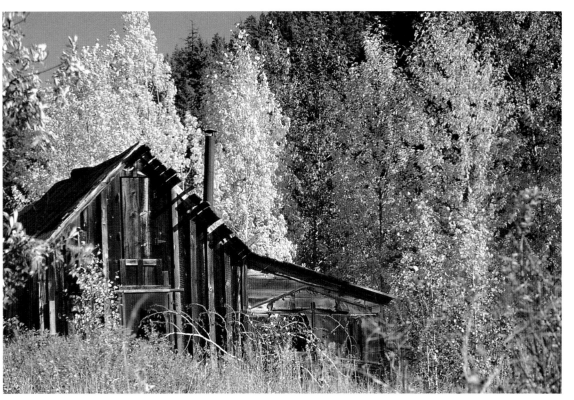
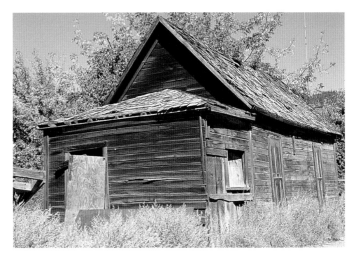
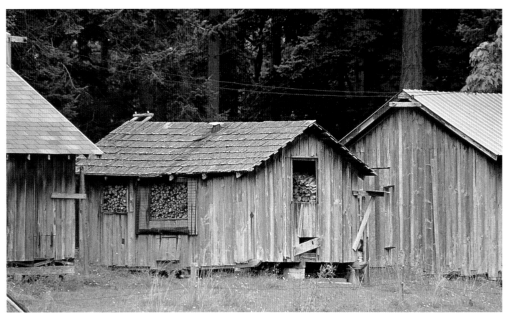

Everything Hinges On... in Colored Pencil

Materials

Brushes
Nos. 4 and 8 round watercolor brushes

No. 14 flat acrylic brush

Other
Arches 300-lb.(640gsm) rough watercolor paper

2B graphite pencil

Lyra Splender pencil (a pigment-free colored pencil for blending)

Kneaded eraser

Electric eraser with Koh-I-Noor imbibed eraser strips

Water container

Paper towels

Cotton balls and cotton swabs

X-Acto knife with a no. 16 blade

Hair dryer (optional)

Small circle template (optional)

Krylon Workable Fixatif

Color Palette

WATER-SOLUBLE COLORED PENCILS

Caran d'Ache Supracolor II Soft—Brownish Beige

Faber-Castell Albrecht Dürer Aquarelle—Burnt Ochre; Cinnamon; Cold Grey I, II and III; Ivory; Light Flesh; Venetian Red

Winsor & Newton Rexel Derwent Watercolor—Blue Gray

OIL-BASED COLORED PENCILS

Caran d'Ache Pablo—Brownish Beige

Faber-Castell Polychromos—Black; Cold Grey I, II, IV, V and VI; Dark Sepia; White; Warm Grey V

WAX-BASED COLORED PENCILS

Winsor & Newton Rexel Cumberland Artist—Blue Gray

Sanford Prismacolor—Burnt Umber, Cloud Blue, Dark Umber, Pumpkin Orange, Sienna Brown, Yellowed Orange

Artists who attempt colored pencil are often frustrated by a lack of results. Their biggest mistakes are trying to apply all of the pigment at one time and using a dull point. The textures in this painting were created by gradually adding the pigment to the white and round boards with layers of fine lines and with evenly applied layers of color. Using rough watercolor paper further enhanced the rough texture of the wood.

This image is a portion of a weathered garage door discovered in Port Townsend, Washington. Quite often, small details that most people miss make exciting subjects.

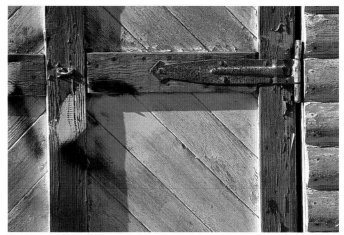

Reference photo

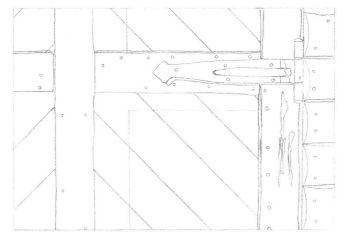

Helpful Hint
Keep pencil points extremely sharp at all times, and apply pigment and water in the same direction as the object's length.

1. Lay Out the Composition
Lay out the painting with a 2B graphite pencil (follow the sketch shown). When the composition is finalized, retrace next to the graphite lines using Cold Grey II and Venetian Red water-soluble colored pencils. Lightly erase all graphite lines with a kneaded eraser so only the colored pencil lines remain.

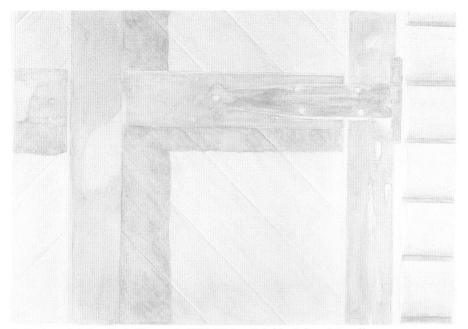

2. Underpaint the Basic Elements With Water-Soluble Colored Pencils

A. Flat white boards. Apply Cold Grey I, leaving the highlight on the right edge free of pigment. Apply water with a nearly dry no. 14 flat brush. Dry with a hair dryer or allow to air dry. Apply Cold Grey III and Blue Gray to shadow areas. Apply water with a nearly dry no. 14 flat brush. Dry with a hair dryer or allow to air dry.

B. Round white boards. For all boards, draw nail heads approximately ³⁄₁₆" (5mm) in diameter with Cold Grey II and a circle template. Leave free of pigment. Apply Cold Grey I, II and III. Lightly wipe with a dry cotton ball. Apply water with a nearly dry no. 14 flat brush. Dry with a hair dryer or allow to air dry.

C. Two-by-fours. Apply Brownish Beige. Leave the highlights, nail heads and white areas free of pigment. Wipe with a cotton ball. Use a cotton swab in tighter areas. Apply water with a nearly dry no. 14 flat brush. Apply Cold Grey I to the white area. Wipe with a cotton swab and apply water with a medium-dry no. 8 round brush. Dry with a hair dryer or allow to air dry.

D. Hasp. Apply Venetian Red and Cinnamon. Leave the highlight areas free of pigment. Wipe with a dry cotton swab. Apply water with a nearly dry no. 14 flat brush. Use a no. 4 round brush in tighter areas. Dry with a hair dryer or allow to air dry.

E. Hinge. Apply Burnt Ochre, Light Flesh and Ivory. Apply water with a no. 4 round brush. Dry with a hair dryer or allow to air dry.

3. Paint White Boards

Note: All pencils used to finish the rest of the painting are either wax or oil based.

A. Illuminated areas. Lightly apply Cloud Blue to the white wood surfaces, leaving the right edges free of pigment for highlight. Apply a heavier application of pigment to the opposite edge as shown. Wipe with a dry cotton ball. Carefully apply thin grain lines with Cold Grey IV, overlapping lines for darker values.

B. Shadowed areas. Lightly apply Black and Cold Grey VI (darkest values only), Blue Gray and Cold Grey IV and V to shadow areas. Lightly remove excess pigment with a dry no. 14 flat brush. Carefully apply thin wood grain lines with Cold Grey V or VI, or Black (darkest values only).

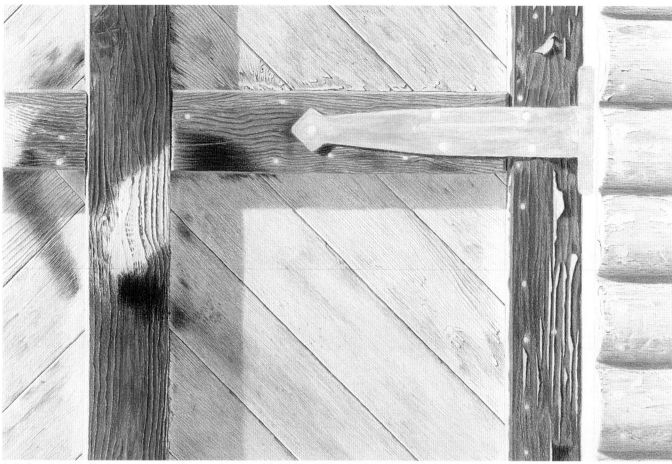

4. Paint the Two-by-Fours

A. Blue paint. Lightly apply Cold Grey VI to cast shadows in areas with blue paint. Lightly apply Blue Gray over shadows. Use slightly more pressure on the darker side of raised areas. Leave the lighter side of raised areas and the peeling paint highlights on the left vertical two-by-four free of pigment. Lightly scrub blue areas with a cotton swab, including the lighter side of raised areas. Do not scrub shadows. Repeat applications of Cold Grey VI and Blue Gray, as above, until a majority of the paper surface is covered. Burnish (blend) blue areas with a Splender pencil. Do not burnish highlights. Repeat applications of Cold Grey VI and Blue Gray, as above. Lightly scrape random areas of blue paint with the flat edge of a no. 16 X-Acto knife blade. Touch up with Blue Gray. Very lightly apply Cloud Blue and Cold Grey I to highlight areas of peeling paint, then lightly burnish with White. Apply Cold Grey II to the upper edge of the horizontal two-by-four. Burnish with a Splender pencil. Apply Cold Grey IV to the lower edge of the horizontal two-by-four, then burnish with a Splender pencil. Apply Blue Gray to the highlighted edges of the vertical two-by-fours. Burnish with White. Repeat until the paper surface is covered.

B. Bare wood. Lightly apply Warm Grey V and Dark Sepia to the shadow areas of bare wood. Lightly apply several layers of Dark Sepia and Brownish Beige to bare wood areas until most of the paper surface is covered. Do not apply pigment to lighter areas for the first few layers. Lightly burnish with a Splender pencil. Randomly apply Brownish Beige over blue paint.

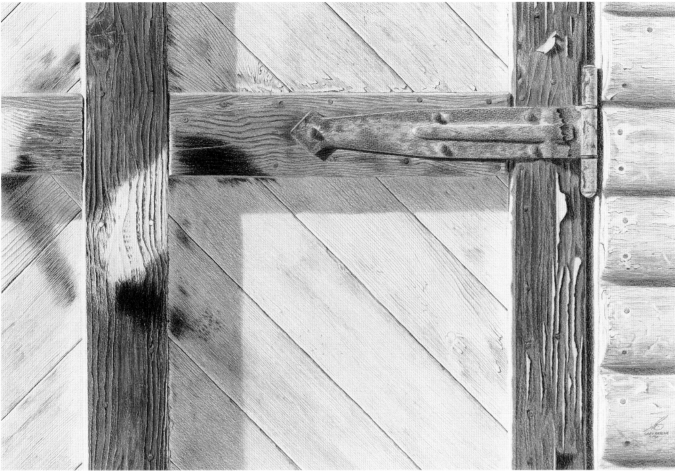

Everything Hinges On...

GARY GREENE

15½" x 23" (39cm x 58cm)

5. Hinge It All Together and Add the Finishing Touches

A. Hasp. Layer shadows with various combinations of Cold Grey VI and Dark Umber. Layer with various combinations of Sienna Brown, Burnt Umber and Pumpkin Orange. Leave the underpainted rivet and highlight areas free of pigment. Layer the highlighted back portion of the hasp with Yellowed Orange. Layer highlights on the front and top edges with Cold Grey I. Layer rivets with gradations of Dark Umber, Burnt Umber and Pumpkin Orange. Layer front edge with Cold Grey II. Layer top edge with Cold Grey I.

B. Hinge. Layer a secondary shadow on the cylinder with Cold Grey V and IV. Layer Sienna Brown and Burnt Umber as shown, leaving portions of underpainting to show through. Burnish dark gaps between hasps with Cold Grey VI.

C. Nail heads. Lightly layer nail heads with Dark Sepia and Burnt Umber. Draw a line on the shadow edge of one-third of the nail heads with Cold Grey VI (blue and white areas) or Dark Umber (bare wood areas). Lightly layer small areas around some nail heads with Burnt Umber.

D. Final touches. Layer a vertical shadow between the two-by-four and round wood with Cold Grey VI and V and Blue Gray, repeating the layering until most of the paper surface is covered. Adjust values with appropriate colors. Lightly apply four to five coats of fixative. Allow to dry after each coat.

Schoolhouses

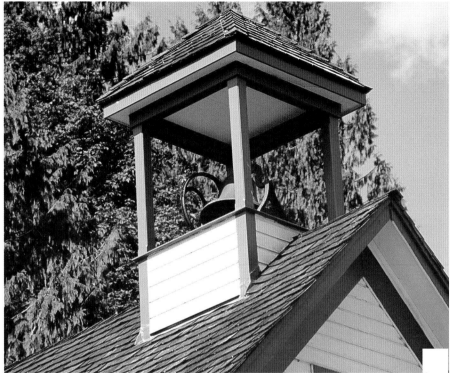

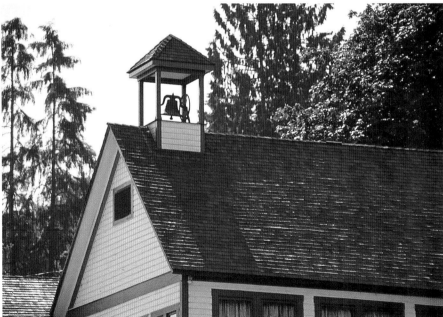

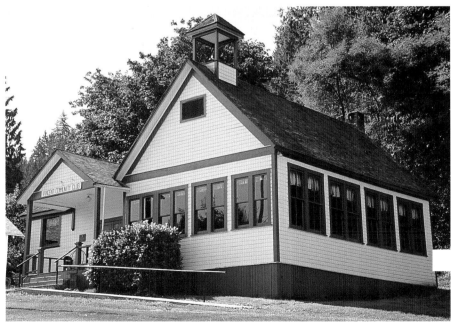

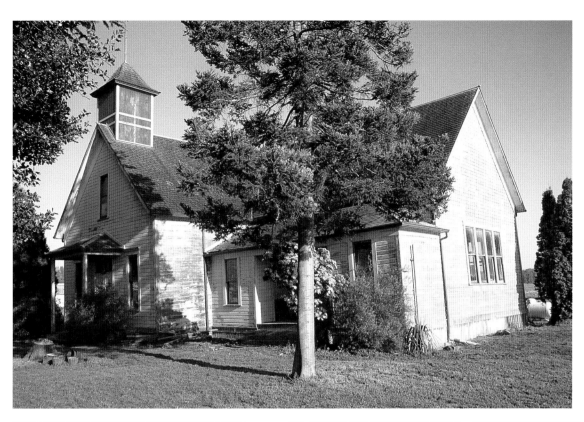

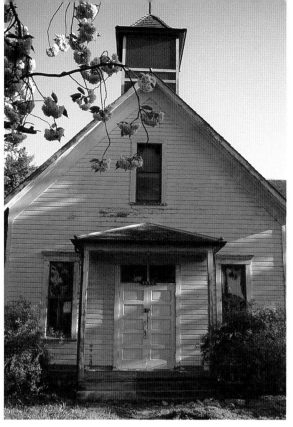

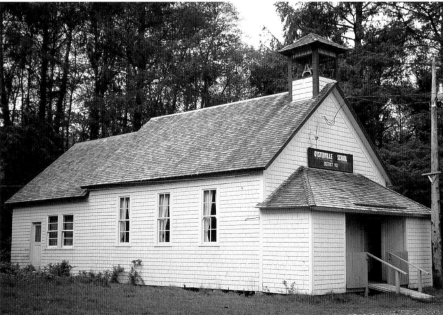

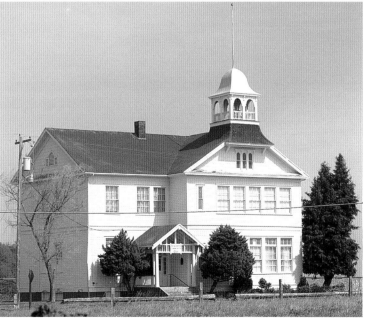

Railroad Stations

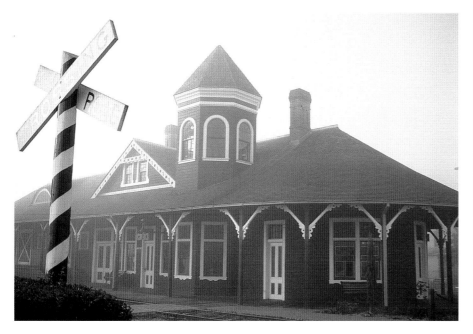

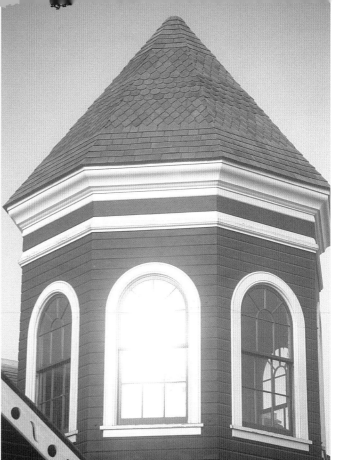

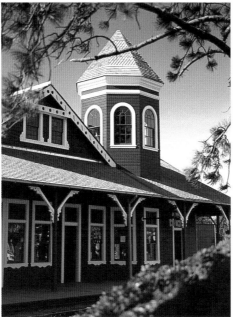

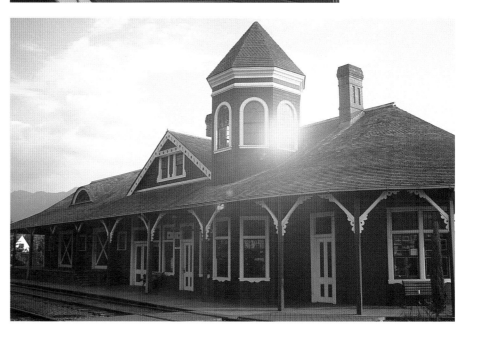

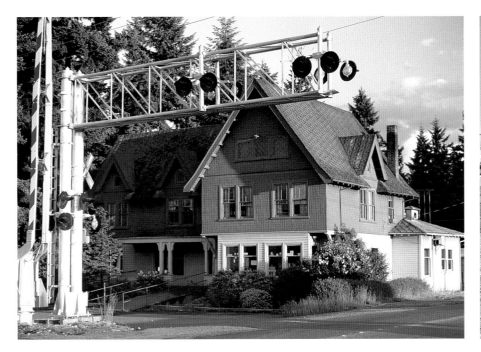

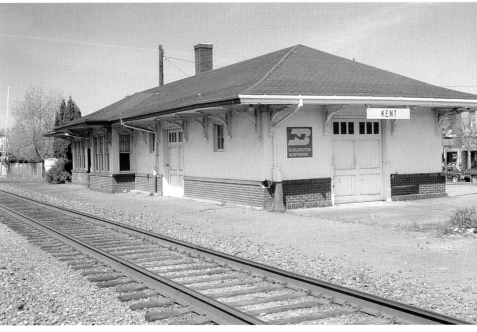

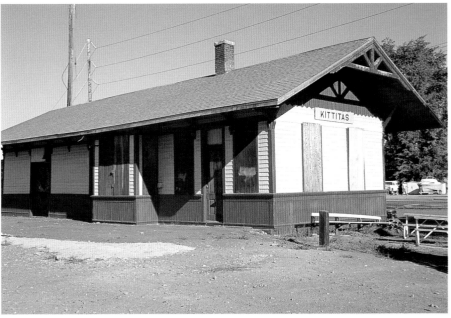

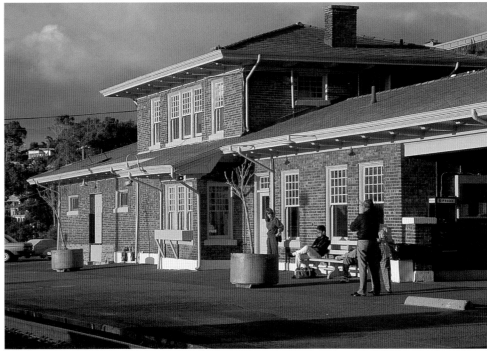

Gas Stations

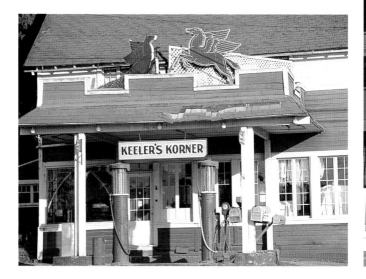

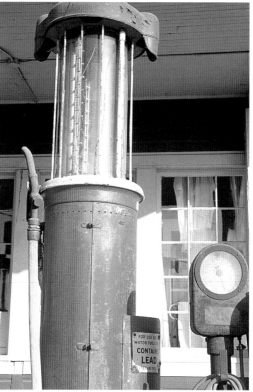

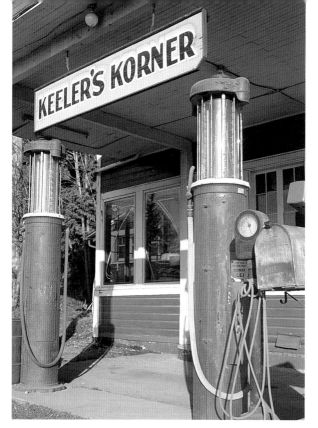

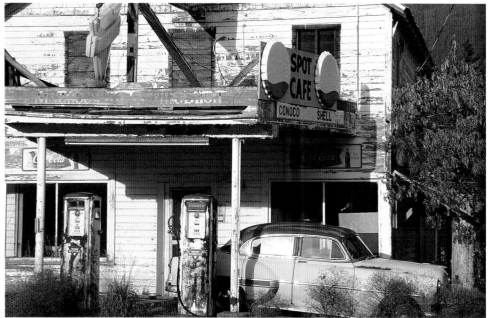

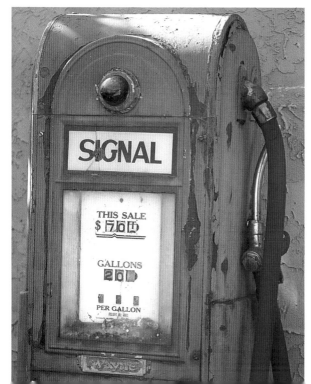

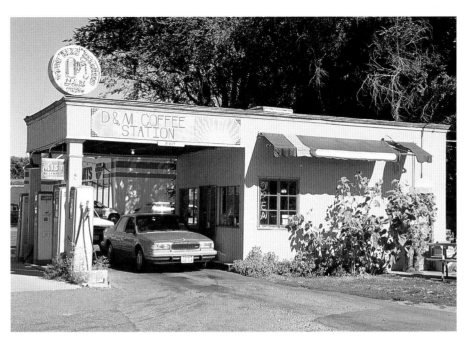

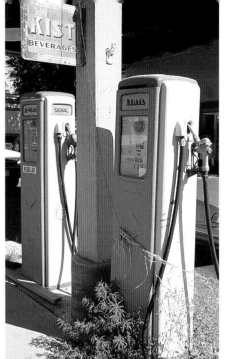

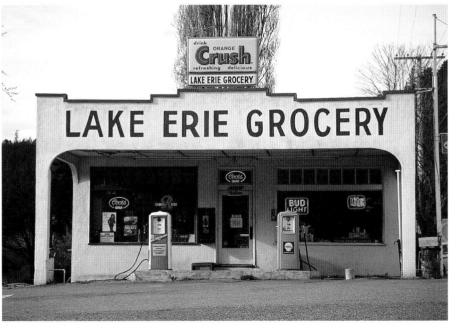

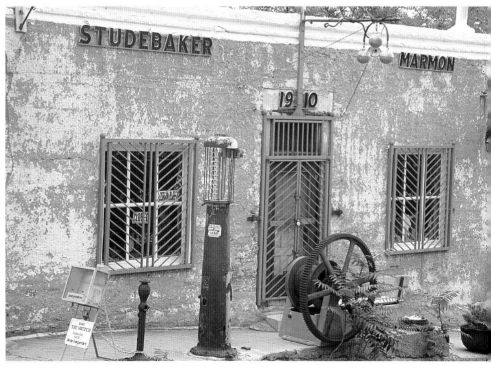

Miscellaneous

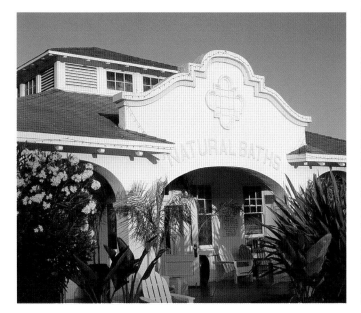

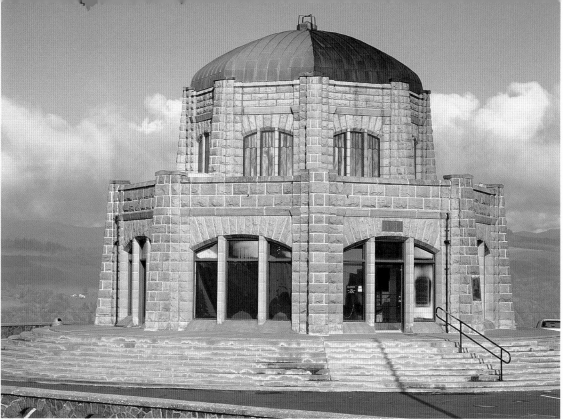

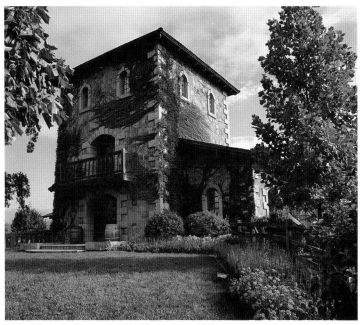

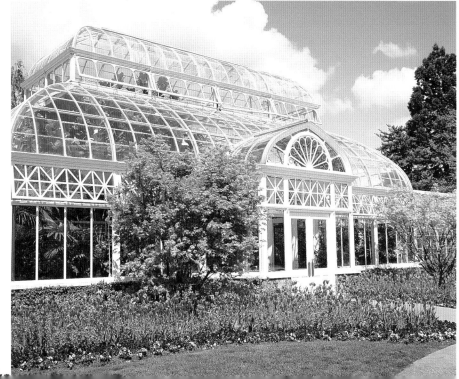

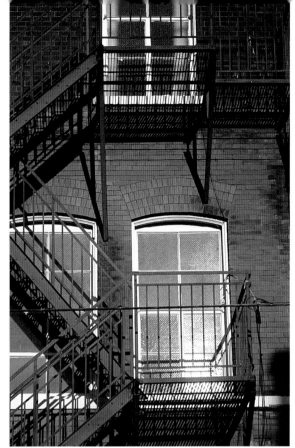

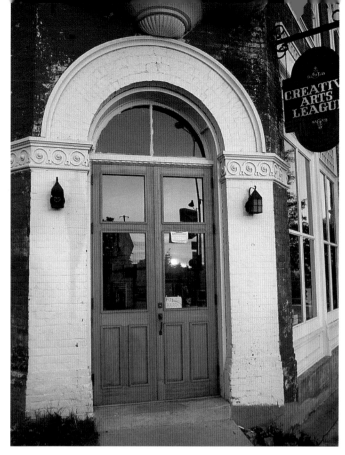

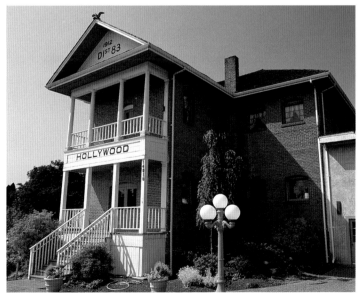

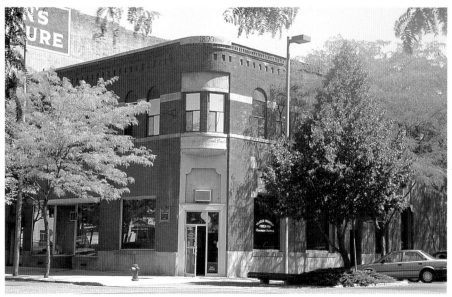

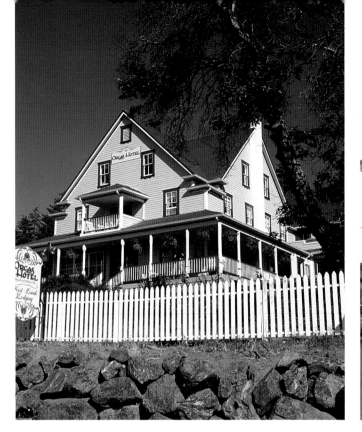

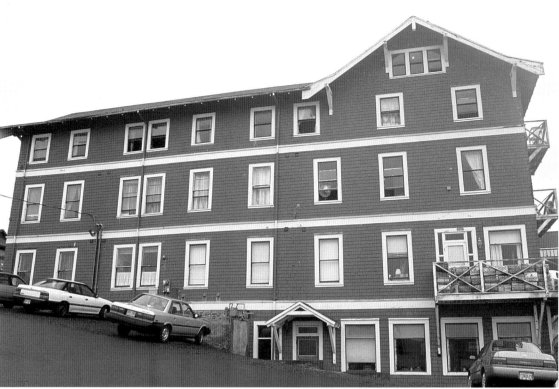

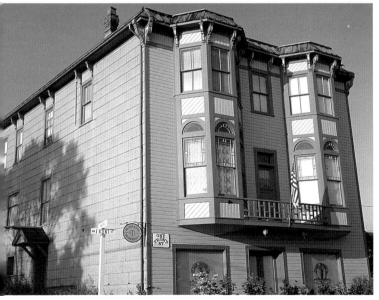

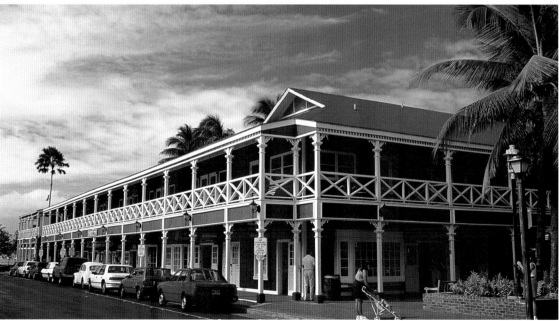

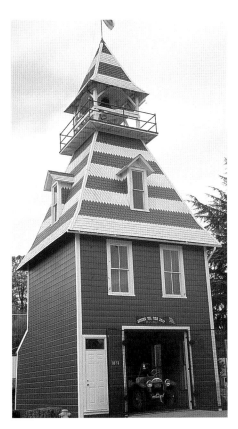

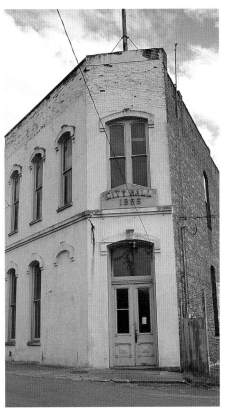

Churches

Churches come in many different shapes and sizes, some with tall steeples, some with none. They are also painted in various colors; however, most are white. Pictured in this chapter are Classic American styles, as well as missions and chapels.

Missions

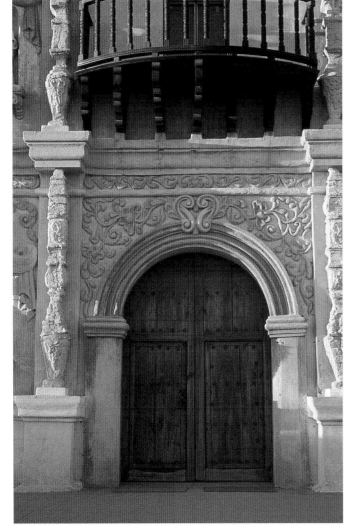

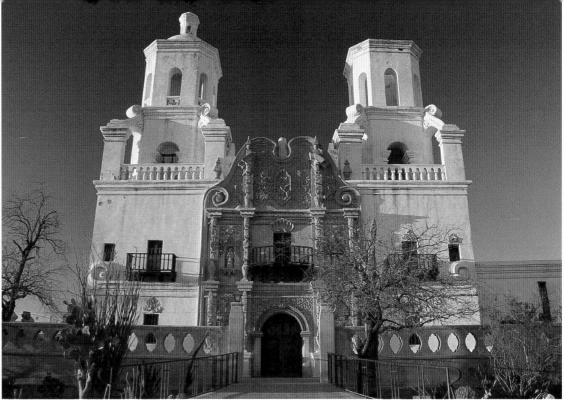

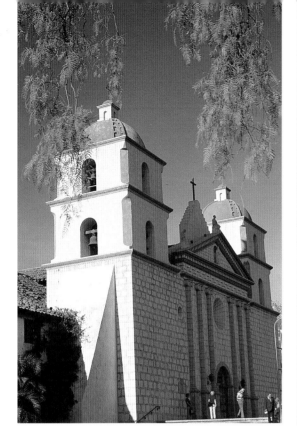

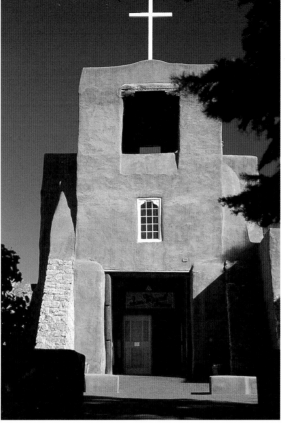

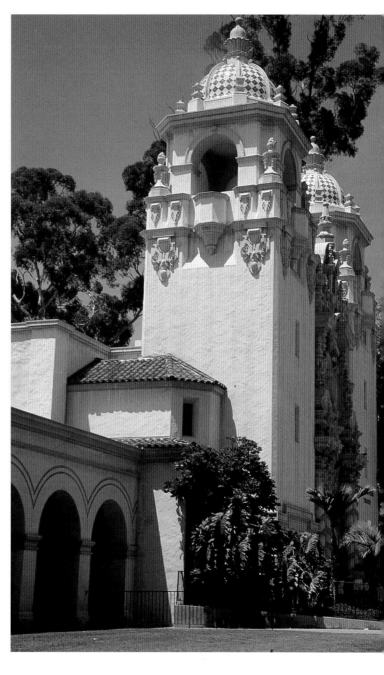

Chapels

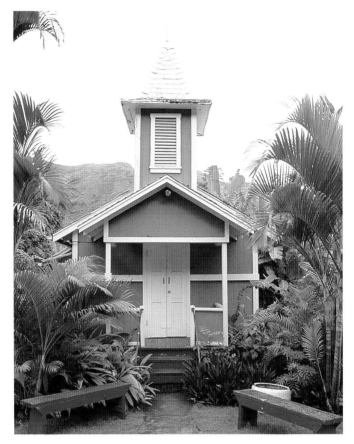

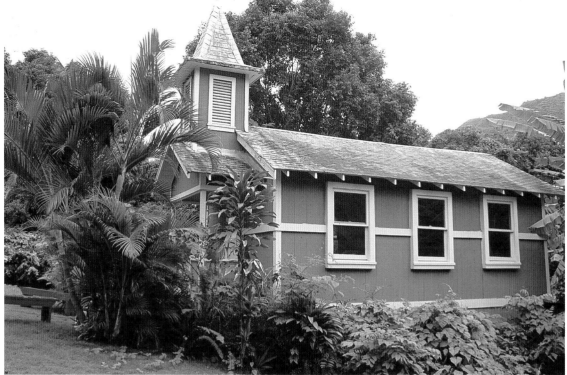

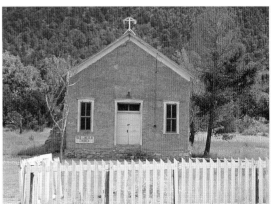

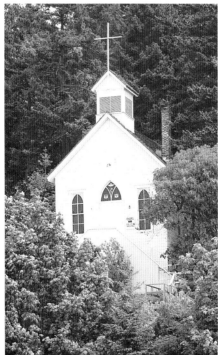

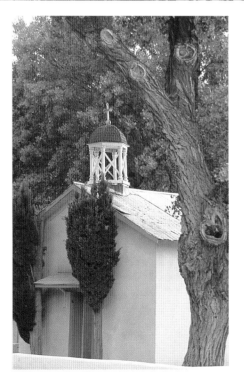

Classic American

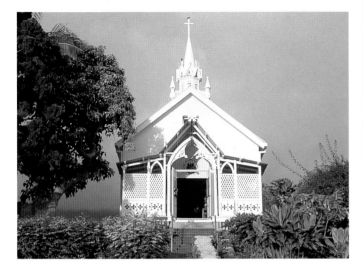

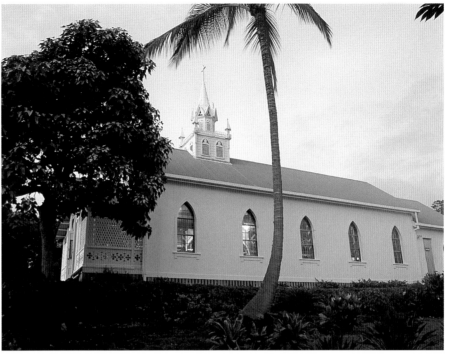

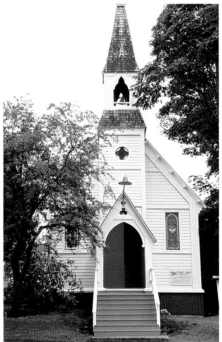

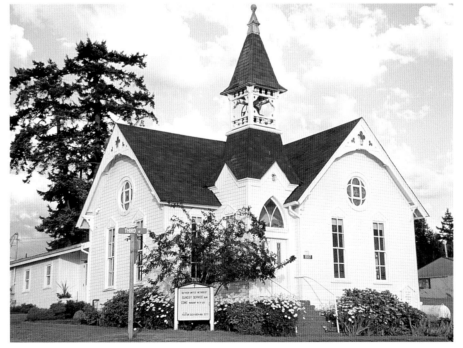

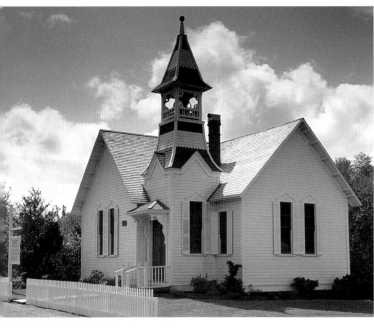

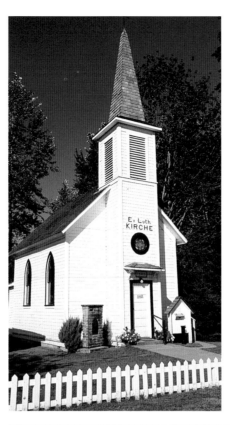

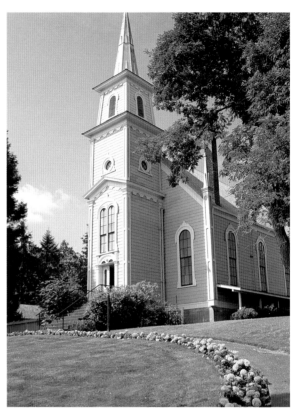

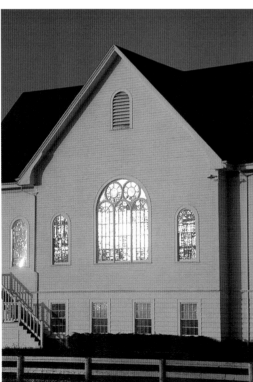

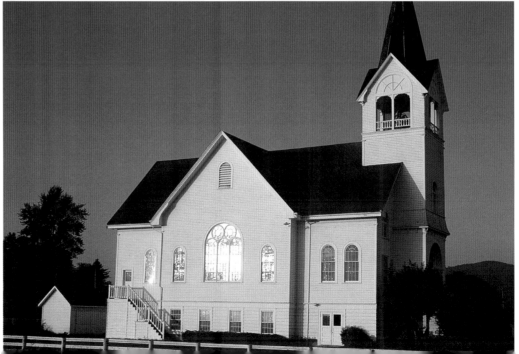

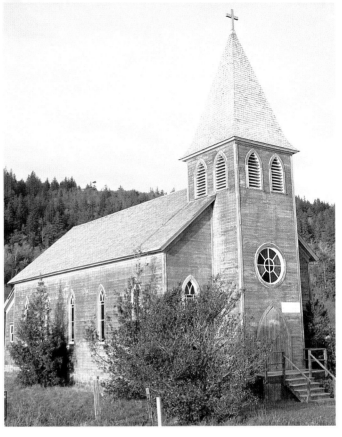

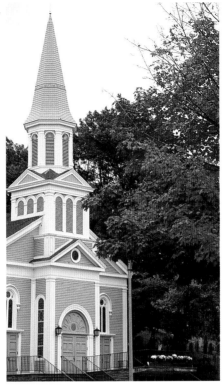

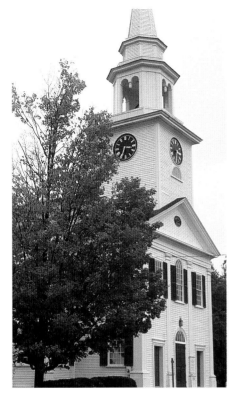

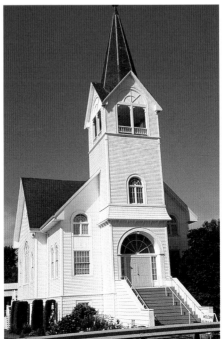

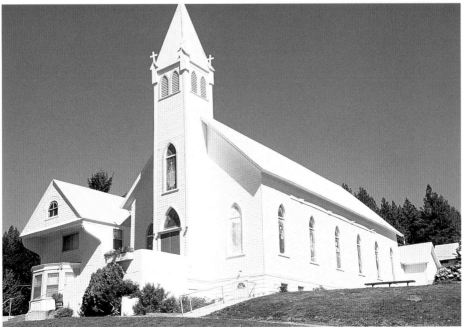

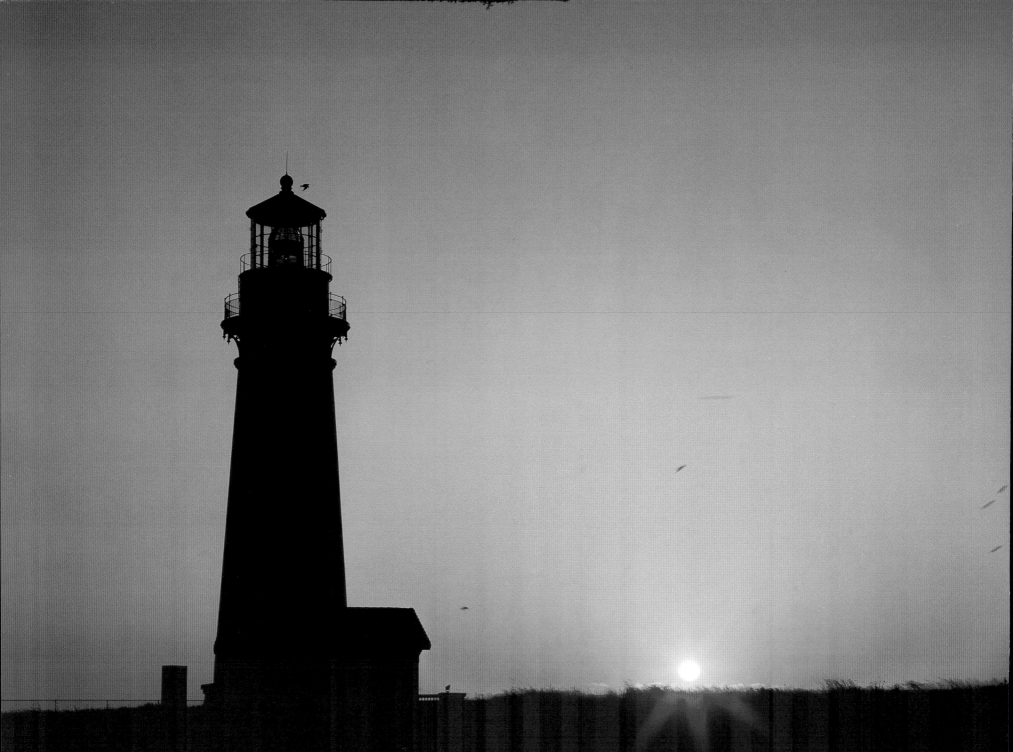

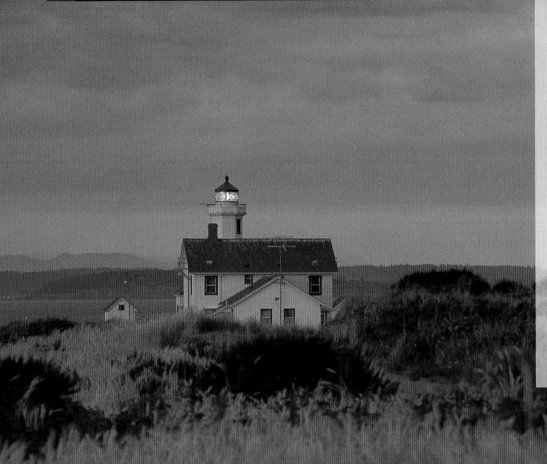

Lighthouses & Other Waterfront Property

With the advent of the technological age, the need for lighthouses has dwindled. These anachronisms stand today as monuments of the past, too beautiful to be torn down. Included here are several examples of these fascinating structures and other picturesque buildings often found by lakes and sea sides.

Waterfront Buildings & Docks

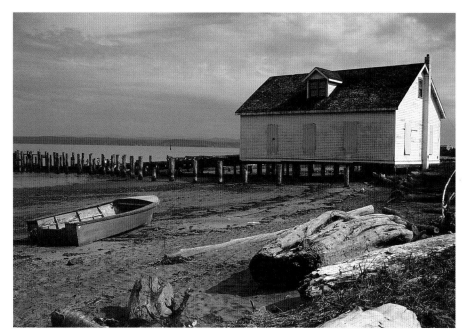

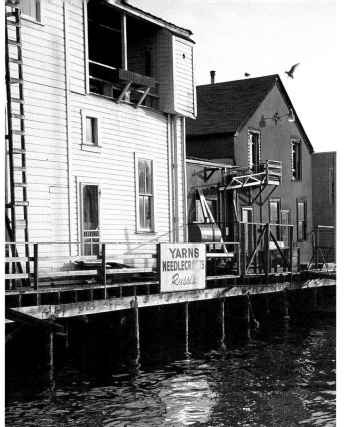

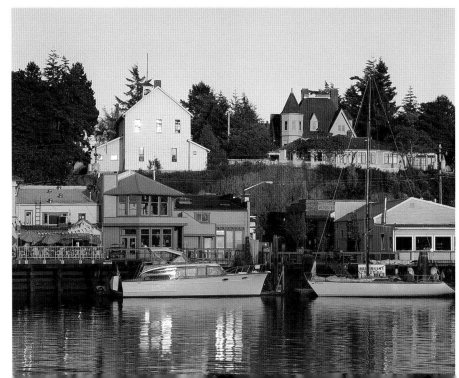

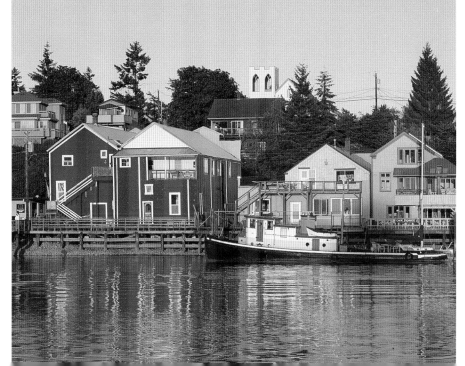

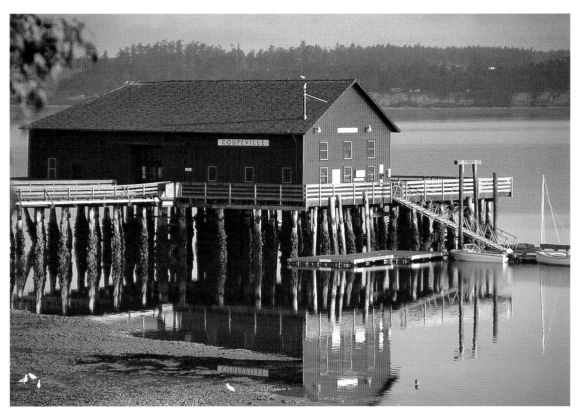

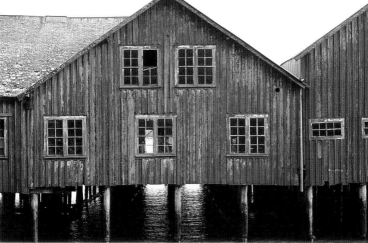

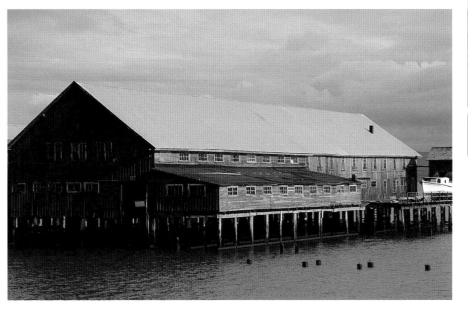

Lighthouses

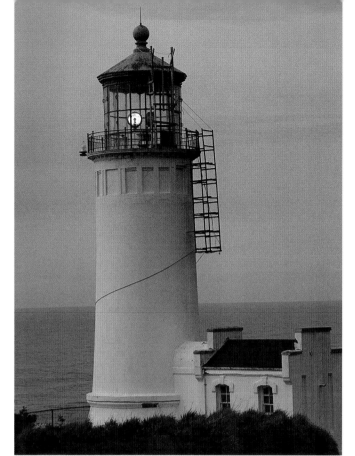

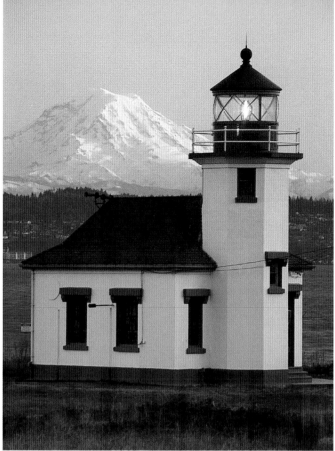

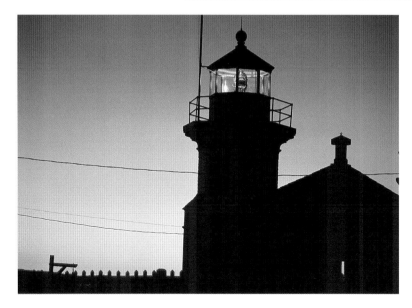

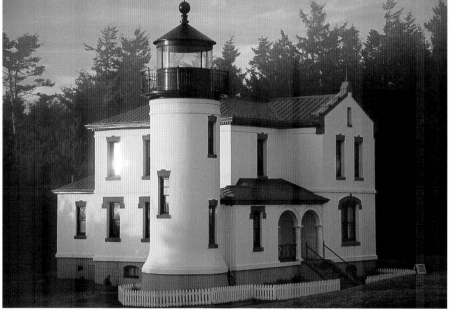

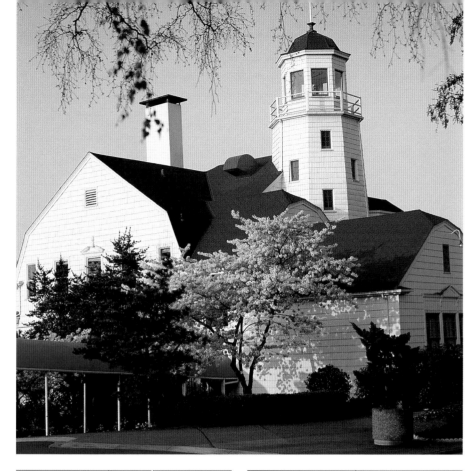

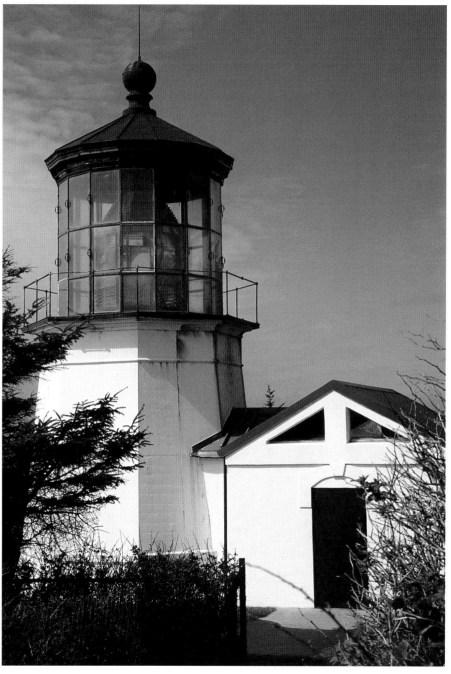

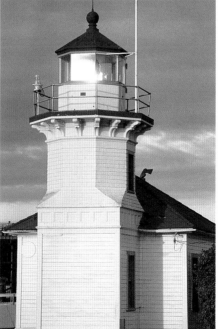

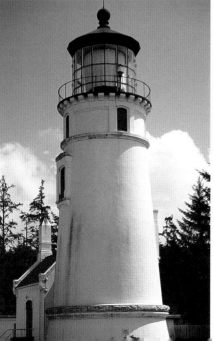

Morning Light at Yaquina Head in Watercolor

Materials

Brushes

1-inch (25mm) Cirrus flat watercolor brush

½-inch (12mm) Winsor & Newton Aquarelle flat brush (with clear handle)

Nos. 4 and 8 round Winsor & Newton Series 7 sable round brushes

2-inch (51mm) Isabey Series 6421 Squirrel wash brush

Other

Black watercolor paint for compositional value sketch

Sketchbook

15" x 20" (38cm x 51cm) 300-lb. (640gsm) cold-press watercolor paper

17" x 22" (43cm x 56cm) Gatorboard (cut 1" [3cm] larger than the borders of the watercolor paper)

4 Boston Bulldog clips

2B graphite pencil and kneaded eraser

Elephant ear sponge, cellulose (kitchen-type) sponge

Hair dryer (optional)

Paper towels

Water container, 1 quart

Jones watercolor palette with brush holder in the lid

Color Palette

Holbein Watercolors—Manganese Blue

Winsor & Newton Watercolors— Alizarin Crimson, Aureolin, Burnt Sienna, Cadmium Orange, French Ultramarine Blue, Ivory Black, New Gamboge, Raw Sienna, Winsor Blue (Green Shade), Winsor Red

The Yaquina Head lighthouse is located in Newport, Oregon, on the spectacular Oregon coast. Michele Cooper, respected watercolorist and instructor, has captured the essence of this magical structure in flowing, impressionistic washes of watercolor, a truly apropos medium.

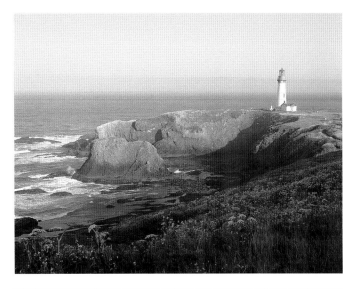

Reference photos

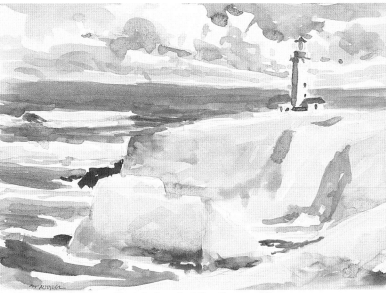

1. After a Preliminary Sketch, Lay Out the Composition

Using Ivory Black and a no. 8 round brush, make a preliminary sketch from the original photographs, working out the composition and value relationships.

Next, clip your watercolor paper to Gatorboard, using Bulldog clips to hold the paper at the corners. Prop it up at a 30- to 90-degree angle. Use a lower angle to maintain better control of the flow of the wet paint.

Lightly draw the horizon line, lighthouse and guidelines to indicate landmasses on the paper. Keep details to a minimum, concentrating more on proportion and placement.

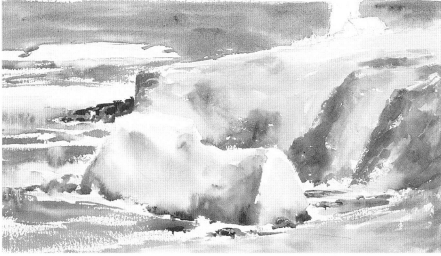

2. Paint the Upper Sky and Sea

Pre-wet the sky background and sea with the elephant ear sponge and water. Reserve the lighthouse space as dry paper by painting around it with plain water using the no. 8 round brush. With a mid-value wash of Manganese Blue and French Ultramarine Blue and the 2-inch (51mm) wash brush, paint the sky above the lighthouse.

Add more French Ultramarine Blue to darken the wash and paint the background sea from left to right on either side of the lighthouse. Reserve the white breaker as dry paper by painting around

it with variations of the darker French Ultramarine Blue and Manganese Blue wash. Use a damp ½-inch (12mm) brush to lift off a reflection under the large white breaker.

Add Alizarin Crimson to French Ultramarine Blue and Manganese Blue for the water to the left of the large foreground rock. Use the side of your 2-inch (51mm) wash brush for a rough texture and soften some edges with a dampened ½-inch (12mm) flat brush. Leave foam and breakers as white paper. Finish all the remaining ocean areas in the same manner. Allow this to dry.

3. Paint the Landmasses

Pre-wet the grassy foreground area with the elephant ear sponge before painting. With the 2-inch (51mm) wash brush, roughly add Raw Sienna into some of the leftover ocean color to create a low-chroma yellow-green. Follow the values in the preliminary sketch.

Pre-wet the entire middle-ground landmass under the lighthouse with the elephant ear sponge. Mix thick and thin variations of Burnt Sienna, French Ultramarine Blue and Raw Sienna for warm and cool, light and dark gradations to indicate shadows and textures.

With the 1-inch (25mm) Cirrus flat watercolor bush, paint the dark cliffs on the far right using various combinations of Burnt Sienna, Raw Sienna, Aureolin and French Ultramarine Blue.

With your no. 8 round brush and mixtures of Winsor Blue, Aureolin, Raw Sienna and Burnt Sienna, paint the

shadows on the cliffs, painting over the previous washes that have dried. Accent edges with thick, rough strokes or soften with a damp brush as desired.

To paint the large foreground rock, pre-wet the rock with the elephant ear sponge. Make sure all adjacent areas are dry so the paint will not bleed into the rock or cause backruns.

Mix warm neutrals with Burnt Sienna and French Ultramarine Blue for the darker shadows and projections. Alternate warm and cool colors as before, as well as light and dark passages. Soften edges with a damp brush. Keep the top and right side lighter.

Intensify the mixture to paint the darkest wet rock behind the large foreground rock. On the left side of the foreground rock, alternate thick paint and water to create a wave-washed look. Seek other areas that could be accented with similar small rocks.

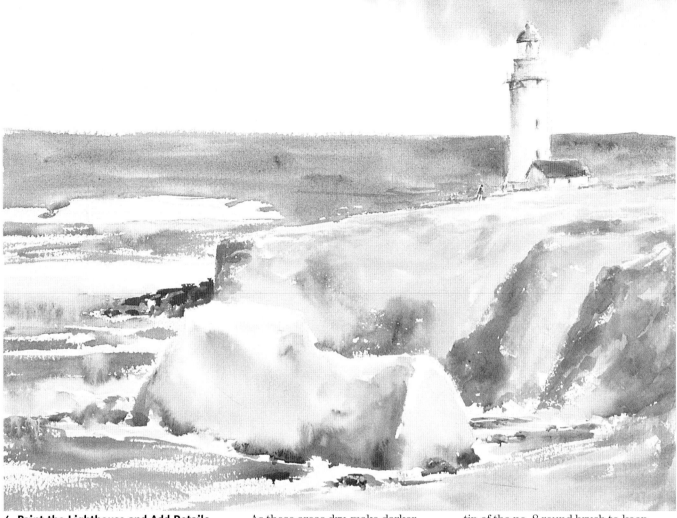

4. Paint the Lighthouse and Add Details

Pre-wet the base of the lighthouse with water using a no. 8 round brush. Load the brush with Manganese Blue and French Ultramarine Blue and stroke it along the length of the left inside edge to give a rounded columnar shape to the base of the lighthouse. Add more Manganese Blue to the brush and paint the left side of the building at the base of the lighthouse.

As these areas dry, make darker accents of French Ultramarine Blue mixed with a little Burnt Sienna under the railing, eaves of the outbuilding and the interior of the light. Soften the lower edge of the light.

Underpaint the roof of the light and outbuilding with Cadmium Orange and add Winsor Red on the left sides wet-into-wet. Introduce plain water on the right side for variation of tone. Use the tip of the no. 8 round brush to keep these details loose.

Underpaint the window shapes on the tower and doorway of the outbuilding with Raw Sienna. Allow to dry. Paint the interior shapes with Burnt Sienna, Manganese Blue or French Ultramarine Blue for variety.

Using the tip of a no. 8 or no. 4 round brush, paint the figure simply as a Winsor Red jacket, small dark head (French Ultramarine Blue plus Burnt Sienna) and white slacks left as white paper, with the background painted on either side of the legs. Use more of the dark green from step 3 under the house and figure to add contrast.

Show reflected light with a light overwash of New Gamboge under the railing and alongside the left side of the lighthouse tower and in the gable end of the outbuilding. Allow to dry.

5. Paint the Breakers, Waves and Clouds

Pre-wet the large breaker to the left of the background cliff with the elephant ear sponge. Using the no. 8 round brush, add Manganese Blue at the edges of the breaker to show form and movement and Manganese Blue plus French Ultramarine Blue at the left edge to show the curl. Repeat for the remaining waves and eddies.

Pre-wet the sky area with the elephant ear sponge from the top of the paper to the top edge of the ocean. Mix Manganese Blue with a little French Ultramarine Blue for the soft contours of clouds. Make them smaller at the horizon and larger at the apex to show perspective. Mix Alizarin Crimson with the previous colors and lower the chroma, if necessary, with a little Raw Sienna and paint the cloud shadows. Save as much white or light paper as possible. Keep it simple so that the sky does not compete with the lighthouse but helps attract the viewer to it as the center of interest. Use the kneaded eraser to eliminate any unwanted pencil marks.

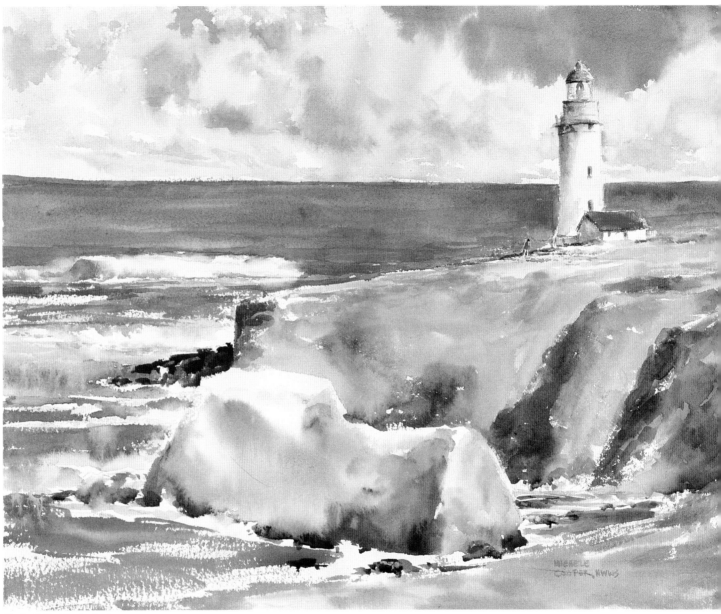

Morning Light at Yaquina Head
MICHELE COOPER
15" x 20" (38cm x 51cm)

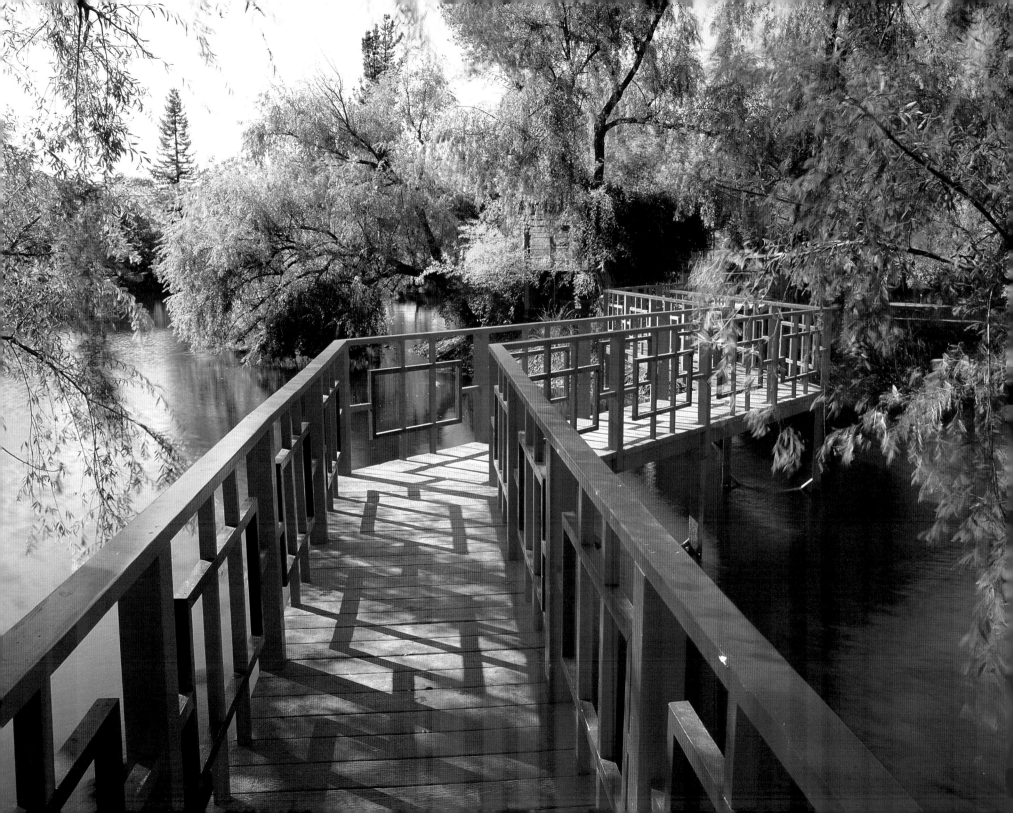

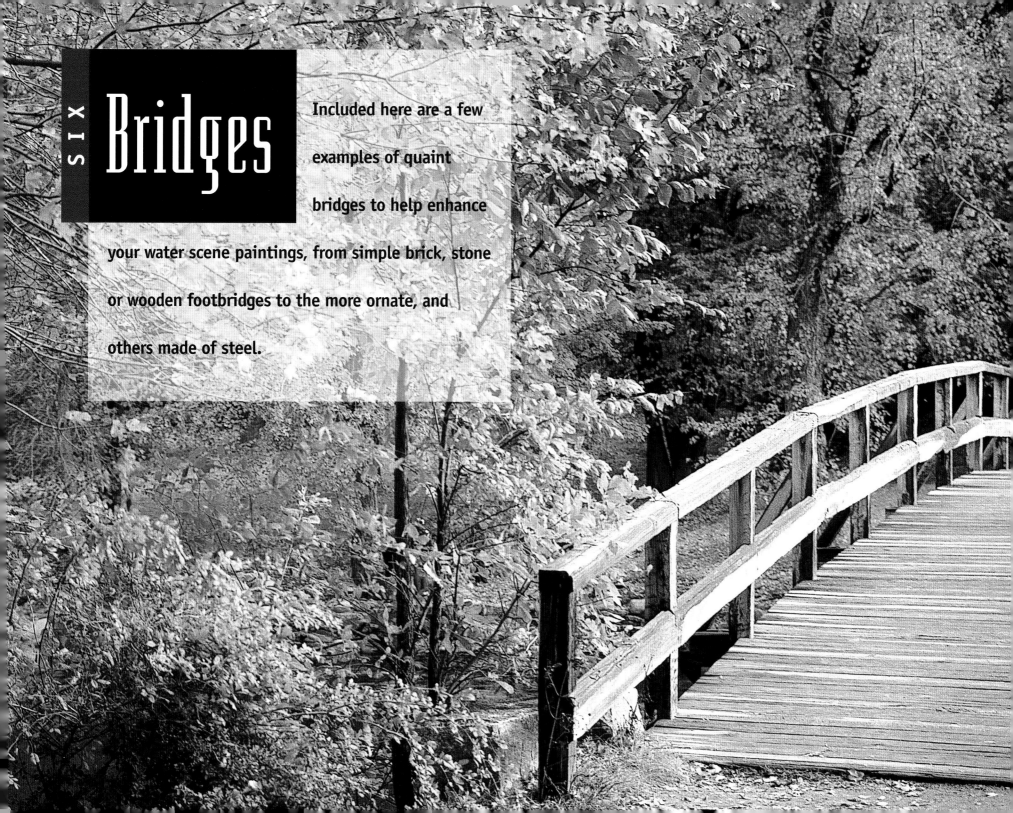

Bridges

SIX

Included here are a few examples of quaint bridges to help enhance your water scene paintings, from simple brick, stone or wooden footbridges to the more ornate, and others made of steel.

Foot

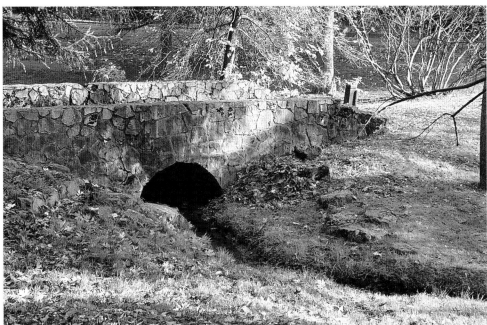

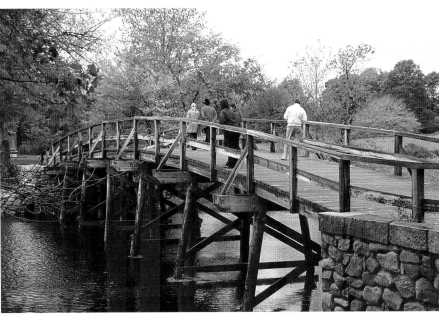

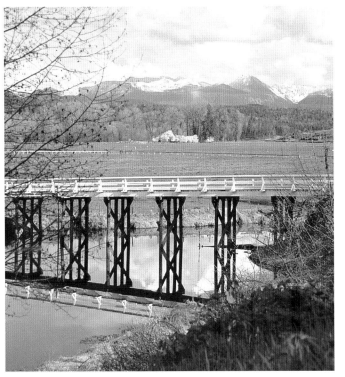

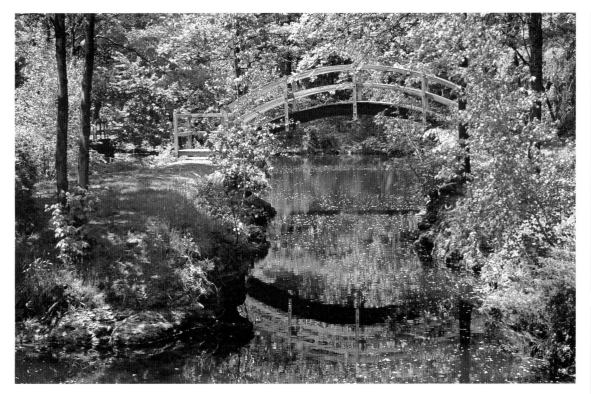

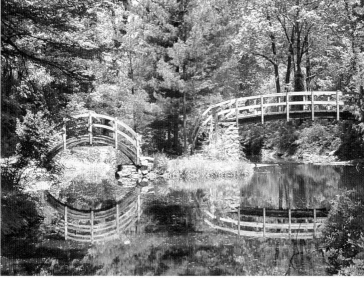

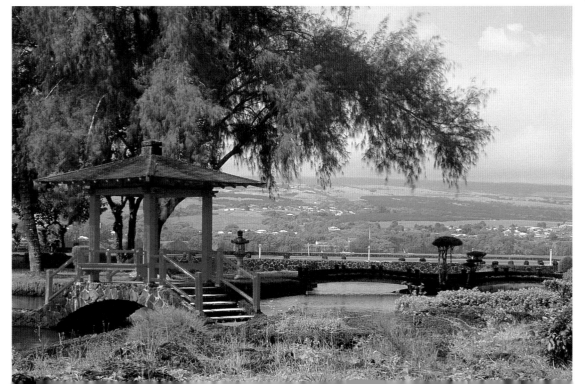

Suspension

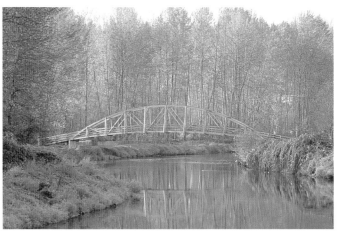

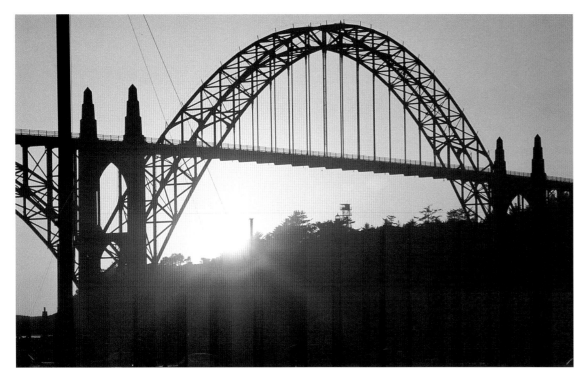

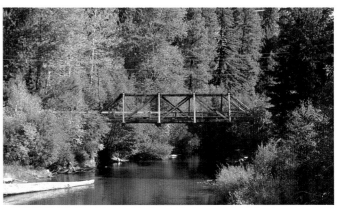

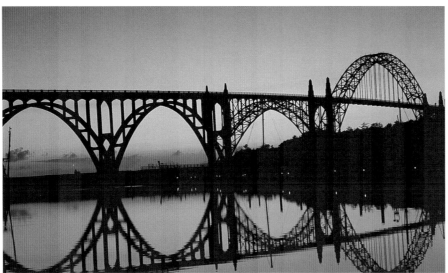

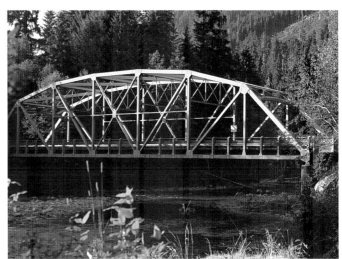

Autumn Bridge in Acrylic

Materials

Brushes

Nos. 2 and 4 synthetic round watercolor brushes

Nos. 4, 8 and 10 synthetic flat watercolor brushes

Nos. 1 and 6 white bristle filbert oil painting brushes

No. 1 white synthetic rigger

2-inch (51mm) brush for applying gesso

Other

Strathmore 500 Series Illustration Board (100 percent rag, acid-free)

Support board

Clips

White gesso

24" (61cm) ruler

Drafting tape

6H graphite pencil

Kneaded eraser

John Pike palette

1¼" (3cm) putty knife to remove dry paint from the paint wells

Razor blade scraper to remove paint from the mixing area

Spray bottle and water container

Golden retarder

Paper towels

Color Palette

Liquitex Acrylic—Burnt Sienna, Burnt Umber, Cadmium Red Medium, Chromium Oxide Green, Cadmium Red Deep (Deep Brilliant Red), Hooker's Green Deep, Indo Orange Red, Maroon, Phthalocyanine Blue, Raw Sienna, Raw Umber, Red Oxide, Titanium White, Ultramarine Blue, Yellow Medium Azo, Yellow Oxide

The covered bridge featured in this painting was photographed near Lincoln City, Oregon, during a typical Oregon coast overcast day.

Linda Tompkin has creatively transformed the scene into this lovely acrylic painting, inspired by the rivers and fall settings of the auxiliary reference photos.

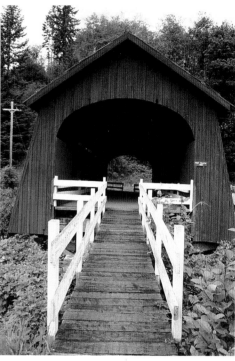

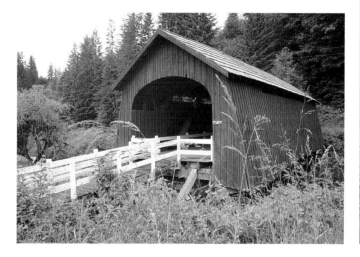

Reference photos

1. Prepare the Painting Surface and Lay Out the Composition

To prepare your painting surface, cut the illustration board 4" (10cm) larger than the image size, allowing 2" (5cm) for a border. Apply a thin coat of gesso to seal the paper. Let dry. Using a ruler and 6H graphite pencil, establish the boundaries of the painting. Mask around drawn lines with drafting tape to keep a clean border while painting. Clip your prepared illustration board to a support board.

Next, lay out the composition using a 6H graphite pencil, then overpaint with a mixture of Raw Umber and Raw Sienna. Use a no. 2 synthetic round brush, adding enough water to the mix to facilitate a clean line. When dry, remove the original pencil lines with a kneaded eraser.

Helpful Hint

To slow the drying time of the acrylic paint on your palette, add one drop of retarder to each of the colors on your palette and mix it in with the paint. This will not appreciably affect the drying time of the paint when it is applied to your work. Periodically mist the paints on your palette with water to keep them from drying out.

2. Paint the Darks and Shadow Sides of All Objects

Using a no. 10 flat brush, paint the opening of the covered bridge using a mixture of Burnt Umber, Ultramarine Blue, Maroon and Titanium White. Paint the dark areas under the bridge with the same colors. A small amount of water may be added to all mixtures, if desired.

For the dark evergreens in the distance, apply a mixture of Hooker's Green Deep, Ultramarine Blue, Raw Sienna, Yellow Oxide and Titanium White with a no. 8 flat brush. For the lighter trees on the distant hill line, use combinations of Titanium White, Phthalo Blue, Hooker's Green Deep and Indo Orange Red.

Using a no. 10 flat brush, paint the shadow side of the bridge and the cast shadow under the eave on the front of the bridge, mixing Red Oxide, Cadmium Red Deep, Burnt Umber, Ultramarine Blue and a little Titanium White. Paint the underside of the eave using Ultramarine Blue, Burnt Umber, Maroon and Titanium White.

Paint the handrails with a no. 4 flat brush. Use Titanium White, Burnt Umber, Burnt Sienna and Ultramarine Blue.

Paint the cast shadow from the bridge with a no. 8 flat brush using Burnt Umber, Ultramarine Blue, Titanium White, Raw Sienna and Hooker's Green Deep. Then place the shadow sides of the rocks on the far side of the river using Titanium White, Burnt Umber and Ultramarine Blue.

Next, place the shadow side of all the trees and bushes using a no. 8 flat brush.

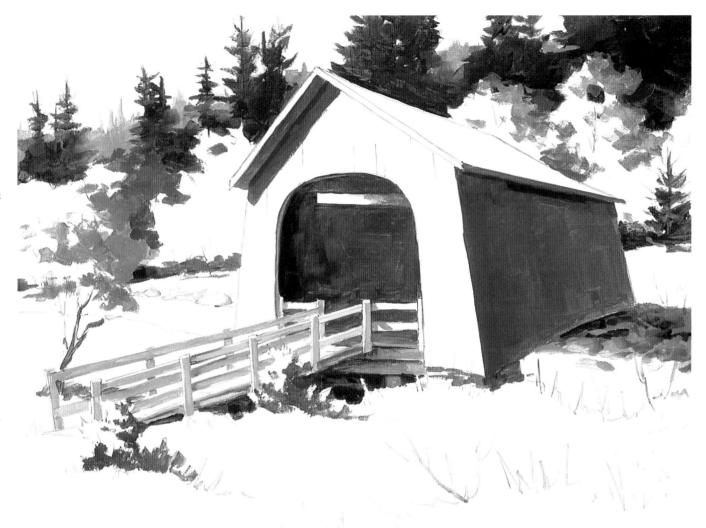

For the red foliage, combine Raw Sienna with Cadmium Red Medium, Maroon and Chromium Oxide Green. Paint the shadow sides of the yellow trees using Raw Sienna, Burnt Sienna, Titanium White and Chromium Oxide Green. Paint the tree behind the footbridge using combinations of Raw Sienna,

Chromium Oxide Green and Burnt Sienna. Place cast shadows from the foreground bushes and the shadows under the distant tree line using combinations of Raw Sienna, Burnt Umber, Ultramarine Blue, Hooker's Green Deep and Titanium White.

3. Paint the Lights

A. Paint the front of the bridge using a no. 10 flat brush with combinations of Titanium White, Red Oxide, Cadmium Red Medium and Yellow Oxide. Add a little Burnt Umber to the mixture under the roof.

B. For the golden trees, use a no. 10 flat brush and varying mixtures of Titanium White, Yellow Oxide, Yellow Medium Azo, Raw Sienna and Red Oxide. Try not to overmix your colors. Let the various colors coexist on your brush, and let them fall randomly throughout the foliage areas. For the red sunlit foliage, use Indo Orange Red, Cadmium Red Medium, Yellow Oxide and Titanium White. Some of the deep evergreen colors used in step two can be used here to create areas within the foliage for the future placement of tree limbs. For the green tree behind the bridge, apply Titanium White, Yellow Oxide and Chromium Oxide Green.

C. Paint the sunlit bank on the far shore with a no. 8 flat brush using Titanium White, Yellow Oxide, Yellow Medium Azo, Raw Sienna and Chromium Oxide Green. Gradually grade the wash darker as it approaches the rocky areas. Place the light gray rocks on the distant shore with a mixture of Titanium White, Burnt Sienna and Ultramarine Blue.

D. For the autumn grasses, use a no. 6 bristle filbert brush, holding the brush midway up the handle and horizontal to your painting surface. With the side of your brush, paint

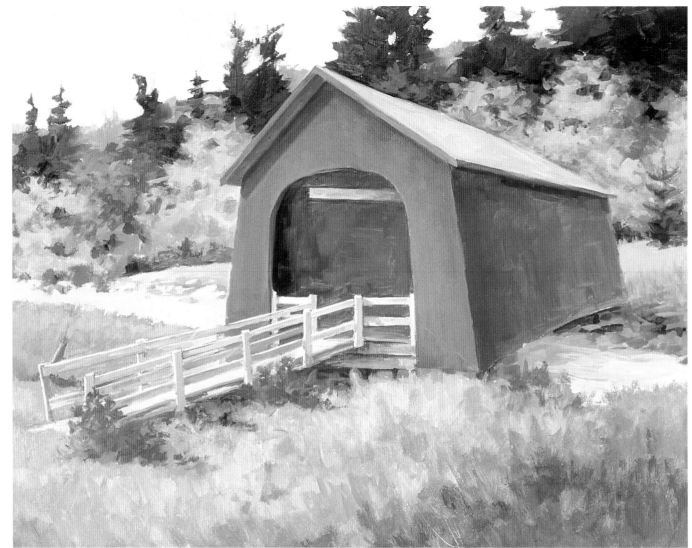

with upward movements from the base of the grass. Start with short strokes in the distance and gradually make the strokes longer as they approach the foreground. Using combinations of Titanium White, Raw Sienna, Yellow Oxide, Red Oxide, Chromium Oxide Green and Hooker's Green Deep, alternate light

and dark values, and warm and cool colors, striving to create texture. Load your brush with a variety of colors and roll the brush as you apply the paint to add variety.

E. Paint the water in the stream with Titanium White, Ultramarine Blue, Phthalo Blue and Burnt Umber, using a no. 8 flat brush.

F. Paint the bridge roof using Titanium White, Burnt Sienna and Ultramarine Blue. Use Titanium White with a small amount of Raw Sienna to highlight the handrail.

G. For the sky, use a no. 8 flat brush and Titanium White, with small amounts of Indo Orange Red and Phthalo Blue.

4. Work From Background to Foreground

Except where noted, the same colors that were used in the first two steps will be used here. Repaint all areas to achieve better coverage, richer color and additional details.

A. Repaint the sky beginning with the blue area. Next, use a no. 10 flat brush to paint the clouds, feathering them into the blue sky. Some of the tree forms will be temporarily lost as you paint the sky.

B. Paint the distant tree line using a no. 4 round brush, dragging the paint in an upward motion to indicate tree shapes. For the dark evergreens, use a no. 1 rigger to establish the trunks for some of the trees. From this center point, use the side of a no. 2 round brush to feather the evergreens into the sky. Small areas of the sky can be painted into the dark mass to show tree structures.

C. Refine the gold and red foliage in the distant autumn trees. Create a lacy effect by painting in small negative shapes. With a no. 2 round brush, add some tree branches and trunks using the same colors that are in the foliage.

D. Paint the grass on the distant shore using a no. 8 flat brush and move down to the rocks, adding more definition to the shapes. Continue by restating the water.

E. Apply another layer of paint to the bridge using a no. 10 flat brush. Deepen the value of the underside of the eave on the front of the bridge.

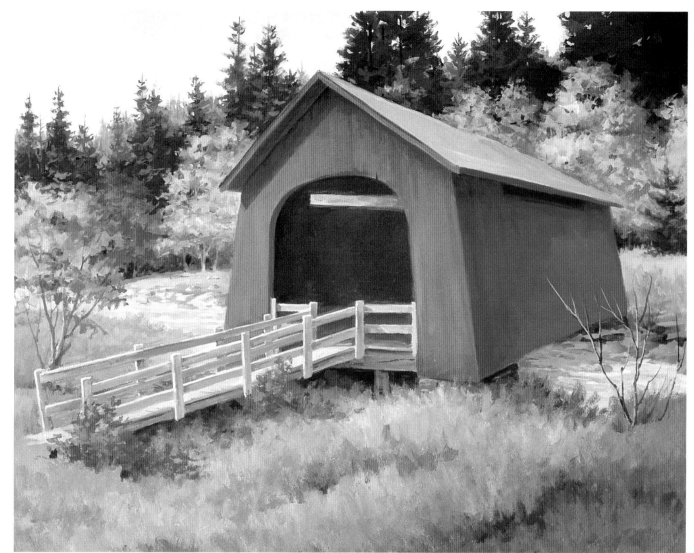

Paint the handrails leading to the bridge using a no. 4 flat brush.

F. Using the no. 1 and no. 6 bristle filbert brushes, repaint the grass areas to create denser color and interesting textures.

G. Add the branches for the bush that will be on the right side using your rigger with a mixture of Burnt Umber, Ultramarine Blue and Titanium White. When using the rigger, add quite a bit of water to your mixture so the paint will flow off the tip of the brush easily.

5. Add Bridge Details

A. With your rigger, indicate the boards in the siding on the shadow side of the bridge using Burnt Umber, Ultramarine Blue and Titanium White.

B. Using Red Oxide, Titanium White and Yellow Oxide and your rigger, paint in some of the textures on the front of the bridge, suggesting boards. Using a no. 4 flat brush, darken some of the boards as they approach the roof with a thin wash of Burnt Umber.

C. Paint the shingles on the bridge roof using a no. 2 round brush. Make a gray by mixing Red Oxide, Ultramarine Blue and Titanium White.

D. With a mixture of Burnt Umber, Ultramarine Blue, Maroon and Titanium White, paint the internal structure of the bridge using a no. 8 flat brush and a no. 4 round brush. Darken the foliage that shows through the opening in the far side of the interior of the bridge with Hooker's Green Deep and Raw Sienna.

E. Paint the foliage on the bush to the right of the bridge using a no. 2 round brush and combinations of Yellow Oxide, Indo Orange Red, Cadmium Red Medium, Maroon and Chromium Oxide Green.

F. Using Titanium White, Hooker's Green Deep and Ultramarine Blue, indicate some lighter branches on the pine trees in the distance. Add a few dead trees for interest using your rigger.

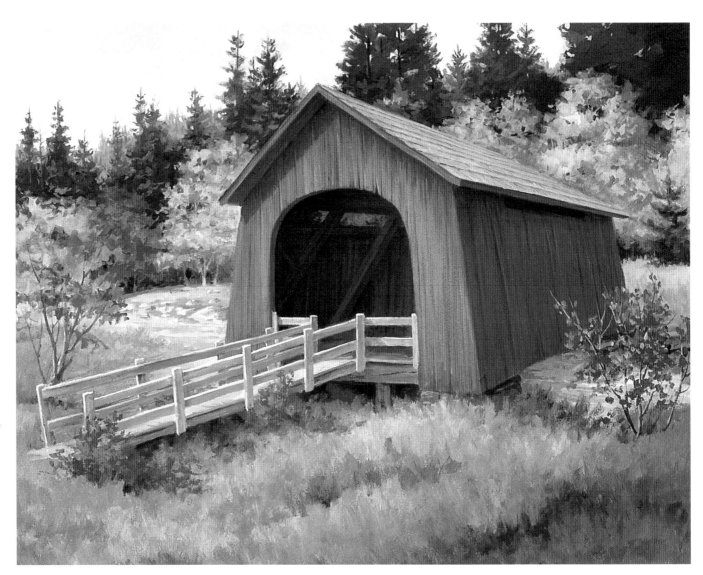

6. Add the Finishing Details

A. With a no. 2 round brush, continue to refine the distant evergreen area by painting in some lighter areas using Titanium White, Hooker's Green Deep and Ultramarine Blue. Also add some darker tree trunks and branches with your rigger.

B. Decrease the intensity of some of the foreground red bushes using a no. 2 round with a combination of Raw Sienna and Red Oxide.

C. With a no. 4 round brush, darken the water behind the red bush using less Titanium White in the mixture of Ultramarine Blue and Burnt Umber.

D. Using a rigger, add some of the dark branches and grasses. Create these dark shapes out of the darker tones already established, superimposing them over the lighter areas of grass.

E. Using the same method and brush, paint the lighter grass. Bring the tall, light grass out of the light areas already established using Titanium White, Yellow Oxide and Raw Sienna. Start your strokes at the base of the grass. Moving your hand upward, let the paint flow off the brush.

F. Randomly place warm leaf colors on some of the foreground branches. If desired, spatter lights and darks into the foreground grass areas. Using a rigger loaded with very wet pigment, tap your brush against the handle of another dry brush to create the spatters. The closer you hold the brush to the surface, the more control you will have over the spatters.

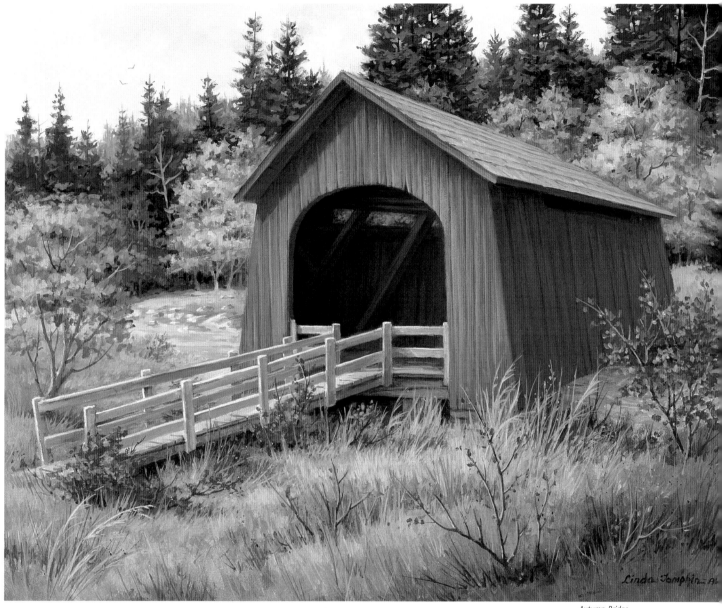

Autumn Bridge
LINDA TOMPKIN
14" x 18" (36cm x 46cm)

Architectural Details

Little things often mean a lot. Larger objects, such
as doors, windows, fences, staircases—and even
smaller objects, such as handles, hinges and brack-
ets—make for interesting paintings in themselves.
These examples should not only serve as reference
material, but should also inspire you to look for the
little things when you're out finding subjects.

Steps

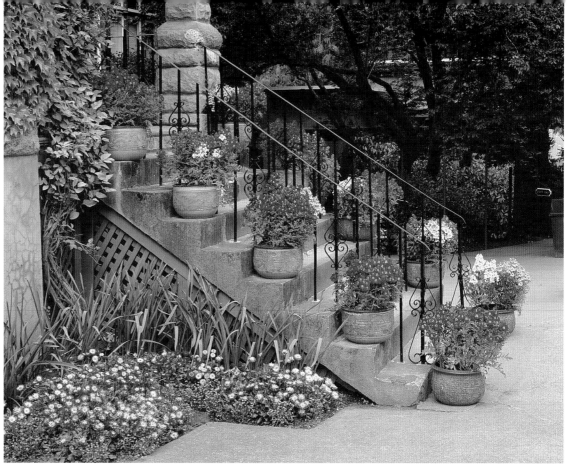

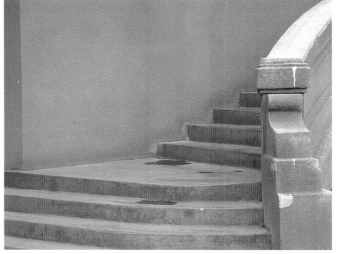

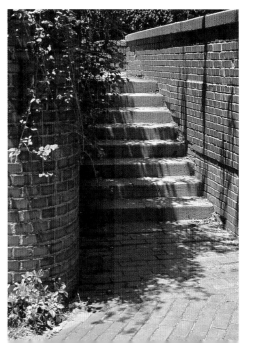

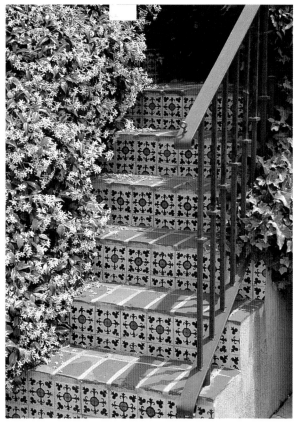

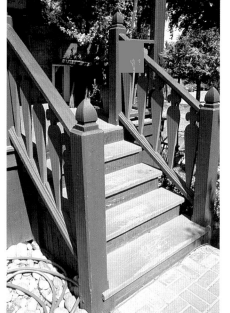

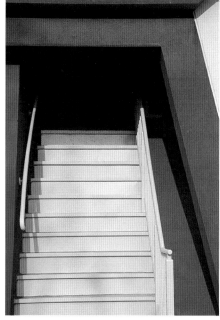

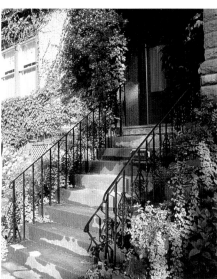

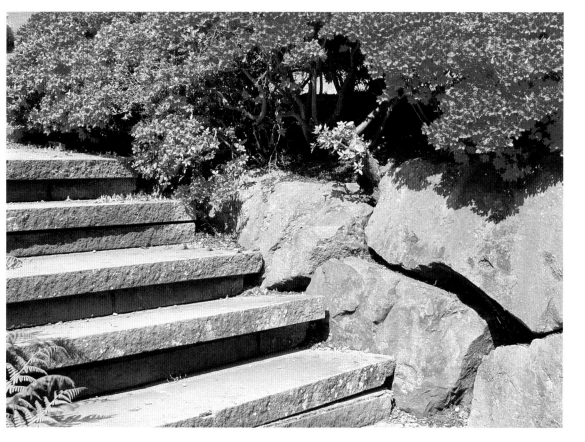

Towers & Turrets

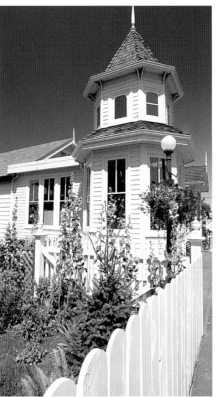

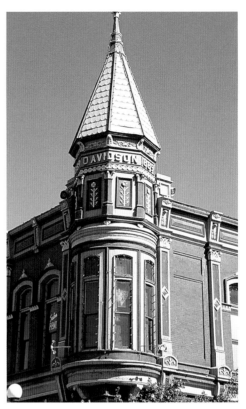

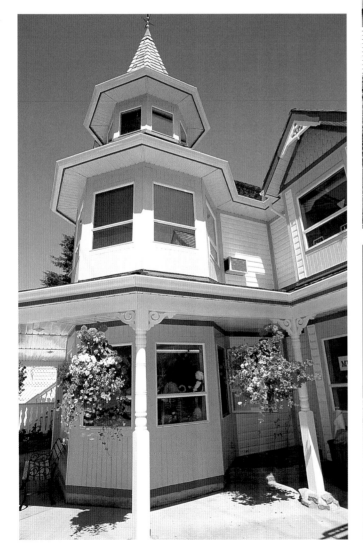

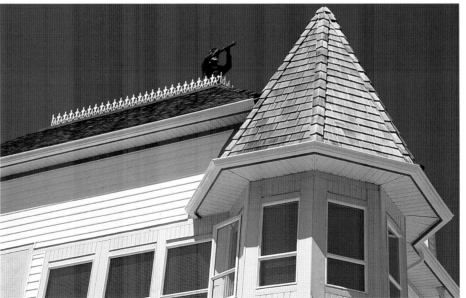

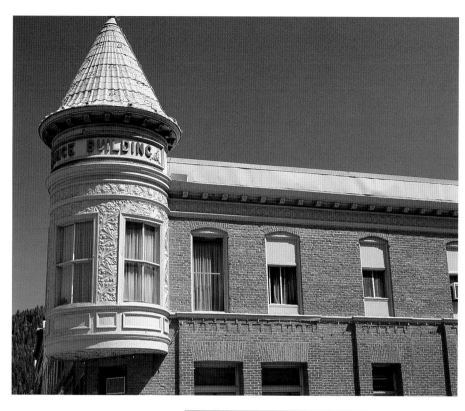
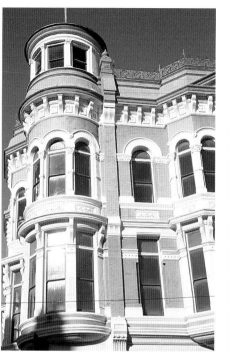
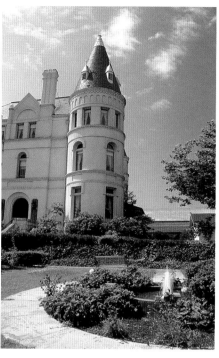
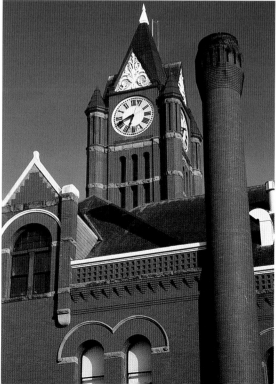
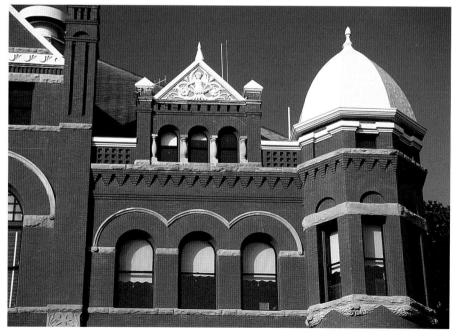

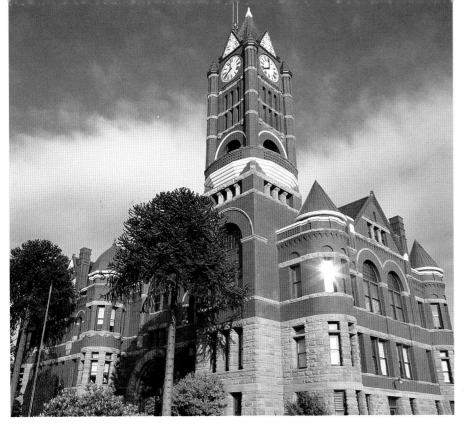

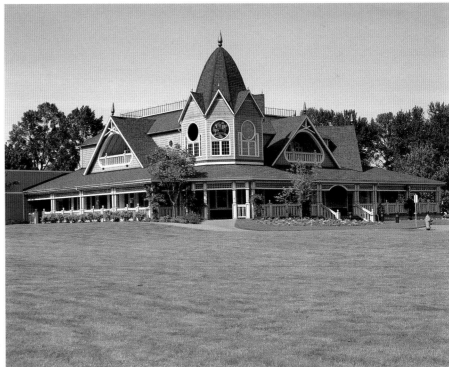

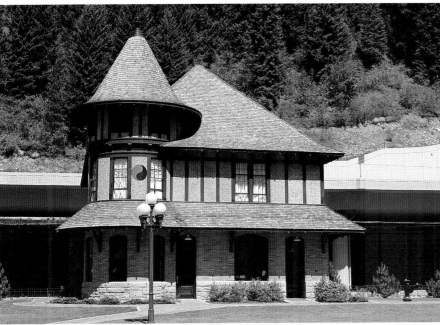

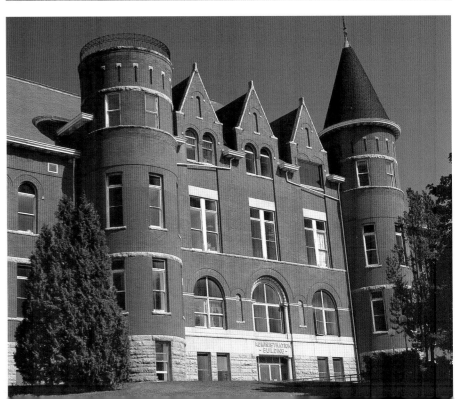

Gazebos

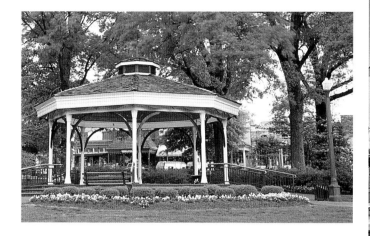

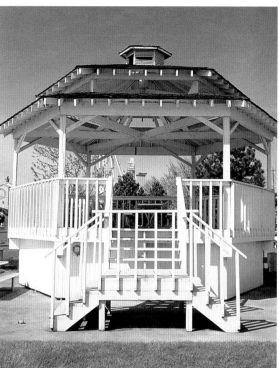

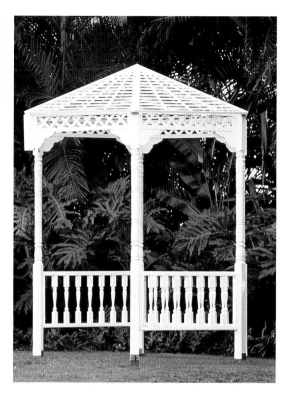

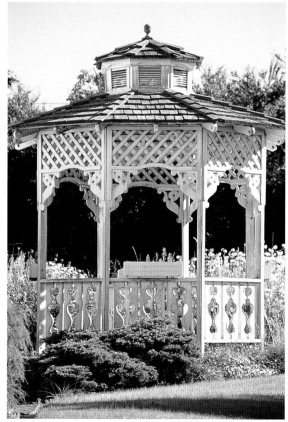

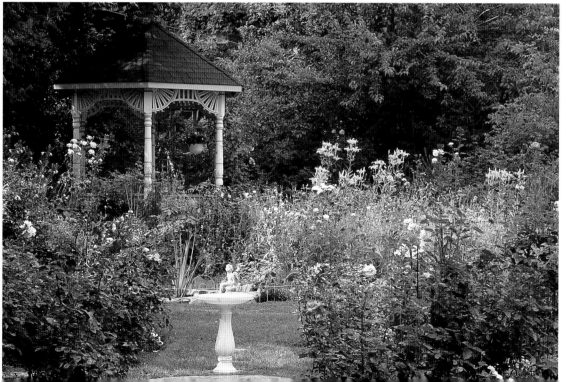

Fences

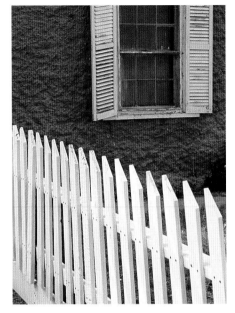

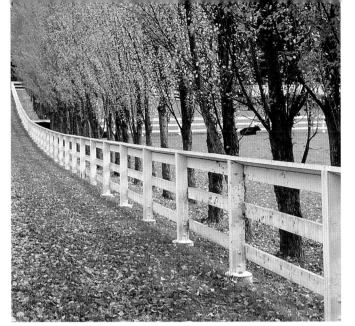

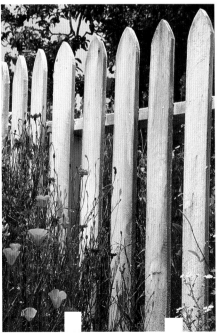

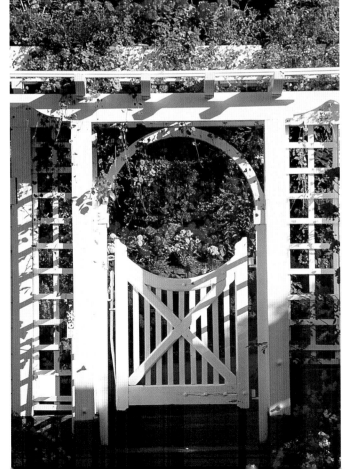

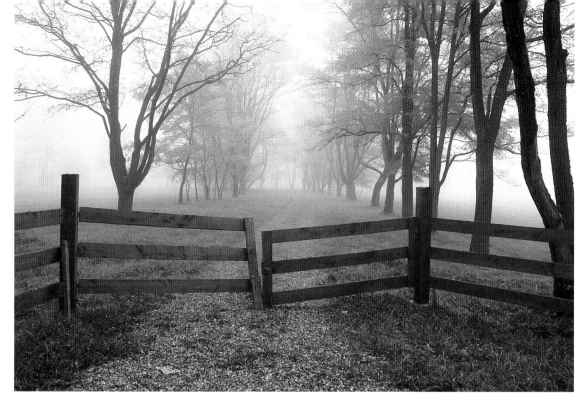

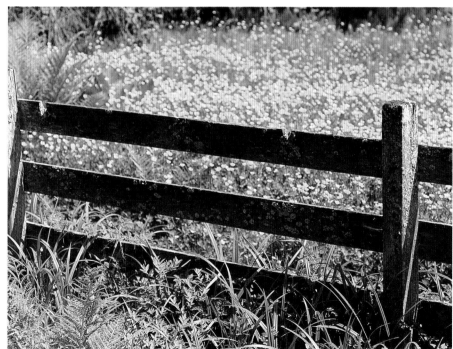

Starrett Mansion in Mixed Media

by Barbara Krans Jenkins

Materials

Brushes

1½-inch (38mm) flat watercolor brushes

Nos. 6 and 8 round watercolor brushes

Other

Strathmore 500 Series illustration board (100-percent rag, acid free)

T-square

Ruler

Drafting tape

0.51mm Pentel mechanical pencil with 2B graphite lead

Sakura cordless eraser with white vinyl eraser

Artgum eraser

Rapidograph Koh-I-Noor mechanical pen (6 x 0 mm nib)

Black India Koh-I-Noor 3074-F Rapidomat ink

Desk brush

Scrap board

Watercolor palette

Krylon Workable Fixatif

Color Palette—Watercolors

Winsor & Newton—Prussian Blue, Sap Green, Neutral Tint

Color Palette—Colored Pencils

Bruynzeel Design Fullcolor—Olive Green

Derwent Artists—Mahogany, Spruce Green, Spruce Blue

Design Spectracolor—Apple Green, Burnt Umber, Grass Green, Olive Green

Faber-Castell Polychromos—Wine Red

Sanford Prismacolor—Apple Green, Black Grape, Blue Slate, Burnt Ochre, Celadon Green, Cream, French Grey 10%, 20%, 30%, 50%, 70% and 90%, Indigo Blue, Jade Green, Light Umber, Lilac, Marine Green, Mediterranean Blue, Metallic Tile Blue, Metallic Green, Olive Green, Warm Grey 70%, White

Rexel Cumberland Derwent Studio—Cedar Green

arbara Krans Jenkins is the definitive detail-oriented artist. She not only researches the visual characteristics of her subjects but also investigates the history, geography and, in this case, construction of her subject.

The result is this amazing ink, watercolor and colored pencil painting of the historic Ann Starrett Mansion in Port Townsend, Washington. By researching the mansion, she was able to add a soaring eagle, common to the region, and a view of Mount Baker.

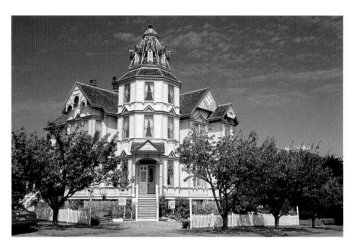

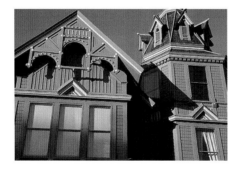

Reference photos

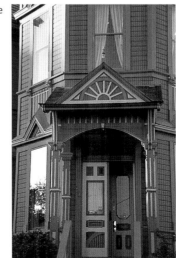

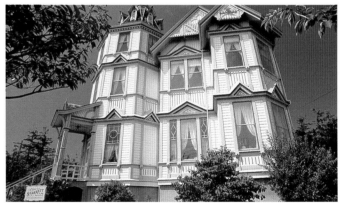

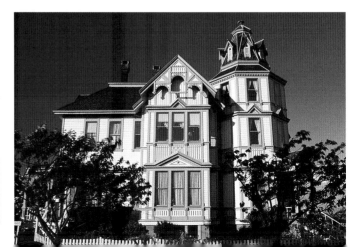

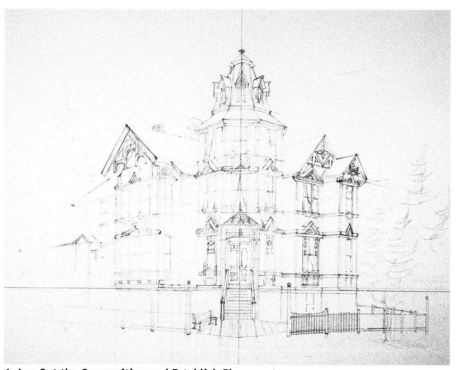

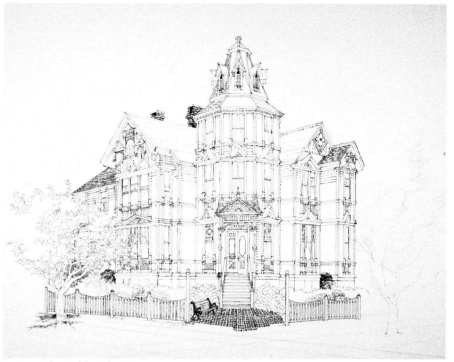

1. Lay Out the Composition and Establish Placement

After taping the illustration board to an oversized drawing board, establish the horizon line and perpendicular compositional centerline with a mechanical pencil. Plot vanishing points approximately 21" (53cm) to the right and 19" (48cm) left of the center line, which will continue off the drawing surface. Then, lightly draw the house with a mechanical pencil, taking care that all the shapes are in correct perspective. (Note: The camera *always* distorts perspective.)

2. Draw the Subject in Ink

With a Koh-I-Noor (6 x 0 mm) pen and permanent ink, draw the building and suggest some landscaping contours in freehand over the pencil guide.

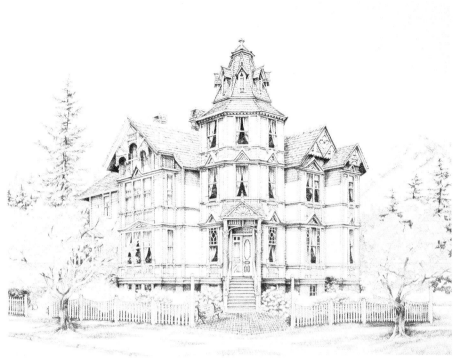

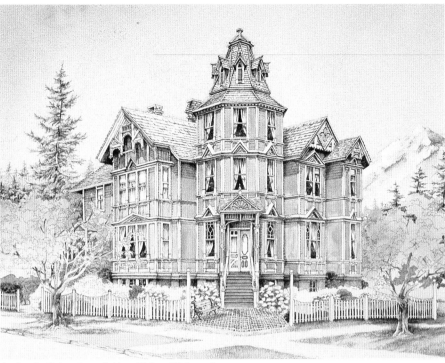

3. Establish Pen and Ink Values

Using crosshatching and stippling techniques with the pen, establish values and textures in the house and setting. When dry, erase the pencil underdrawing.

Crosshatching & Stippling

Crosshatching is a technique of drawing different-length straight or curved lines that cross each other to build a darker area. *Stippling* is a technique of making repetitive dots with the tool point. The closer together the dots are, the more dense or dark the effect.

4. Apply Color Foundation Using Watercolor

Mix a pool of sky color with Prussian Blue and Neutral Tint. Generously wet the board in the sky areas using clean water and a flat brush. Using a no. 8 round brush, apply the pigment from the pool in varying concentrations, along with washes of individual colors so it is darker at the top.

Mix a pool of house base color from Sap Green, Neutral Tint and Prussian Blue, and apply in varying concentrations using nos. 6 and 8 round brushes.

Vary the pool color and paint in the landscaping base colors. Allow to dry.

5. Colored Pencil Finish

Using colored pencils, layer and burnish colors over the watercolor base. Use the scrap board as a hand rest to keep skin oils off the surface of the art.

Working from top to bottom, side to side, begin to lay in colors. When finished, spray the completed piece with three light layers of fixative.

A. **Sky.** Use a mixture of all the blues, Black Grape, Wine Red and French grays, burnishing with White and French Grey 10%.

B. **Background.** For the distant trees and atmosphere, work with layers of all the greens, Metallic Tile Blue, Indigo Blue and French Grey 20%, 30% and 50%.

C. **Foreground.** Start the foreground trees with Apple, Olive, Marine and Celadon greens, Mediterranean Blue and Metallic Tile Blue. Finish the trees with Wine Red, Mahogany, all browns and French Grey 30% and 50%. Burnish with Light Umber, Black Grape, Mahogany, White and French Grey 10% and 20%.

D. **Middle ground.** Layer with Metallic Tile Blue, Mediterranean Blue, Spruce Green and Olive Green, then burnish with French Grey 20%.

E. **Fence.** Burnish with French Grey 10% (in areas getting more light) and 30% (in shaded areas).

F. **Shrubs.** Layer in the shrubs behind the fence with Metallic Blue, Cedar Green and Spruce Green. Burnish with French Grey 20%. For the house shrubs, layer with all of the greens, Metallic Tile Blue, Spruce Blue and Lilac (Hydrangea), and burnish with French Grey 10% and White.

G. **House, base.** Use Jade Green, Celadon Green and Metallic Green for the base color of the house. Burnish with White and French Grey 10% and 20%.

H. **House, trim.** Burnish the primary trim color with French Grey 10% and 20% and White. Layer in the secondary house trim and bench colors with a light layer of Metallic Blue and a heavier layer of Spruce Green. Burnish with White and French Grey 10%.

I. **Accent trim.** Use Mahogany and French Grey 20%.

J. **Window sashes.** For the window sashes, use Black Grape and Wine Red. Burnish with French Grey 20%. Use Cream, White and French Grey 10%, 30% and 50% for the shades and drapes. Burnish the openings with French Grey 90%, Warm Grey 70% and Black Grape.

K. **Roof.** Use Black Grape, Warm Grey 70% and all the browns and French grays.

L. **Brick walk.** Use Mahogany, Black Grape, Burnt Ochre, Burnt Umber and all the French grays for the brick walk and the chimneys.

M. **Mountains.** Use Blue Slate, Black Grape, Metallic Blue and Lilac. Burnish with White and French Grey 10%, 30% and 50%.

N. **Grass.** Use Grass Green, Olive Green and Spruce Green, then burnish with White and French Grey 10% and 30%.

O. **Animals.** For the bald eagles, birds and squirrels, use all the browns, Warm Grey 70% and French Grey 30%. Use your electric eraser to remove the sky pigment and expose the white paper surface for the heads and tails of the eagles, then add the birds.

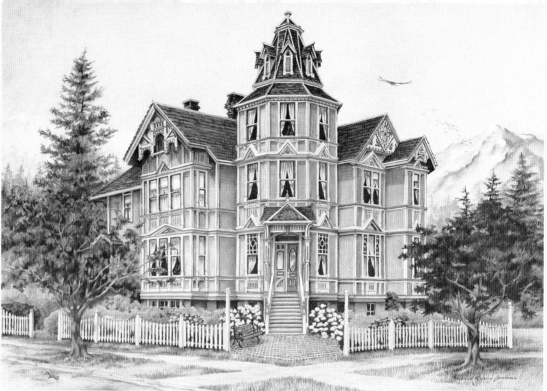

Starrett Mansion, Port Townsend, Washington

BARBARA KRANS JENKINS

12" x 15½" (30cm x 39cm)

Layering & Burnishing

Layering is the light application of colors, allowing the paper surface to show through. *Burnishing* is achieved by pressing down hard and working in a circular motion to pick up the previously layered colors and blend them into a new color.

Arches

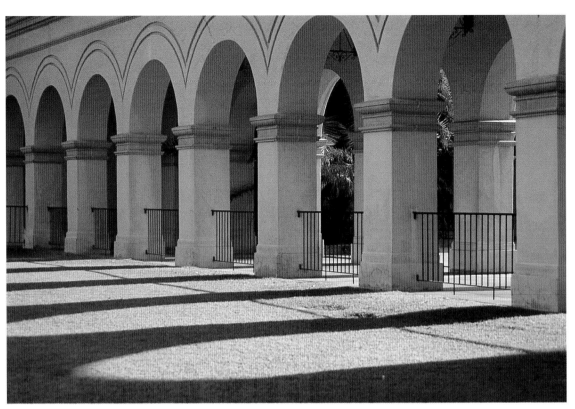

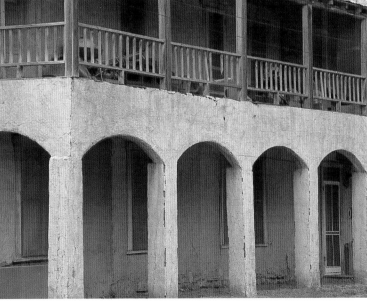

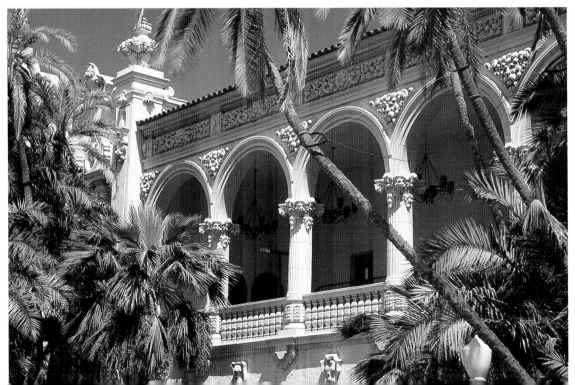

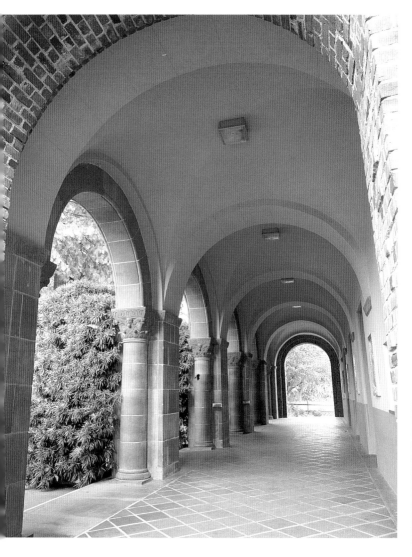
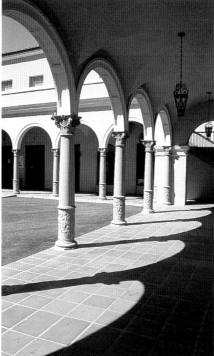
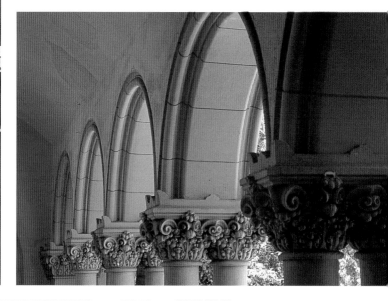
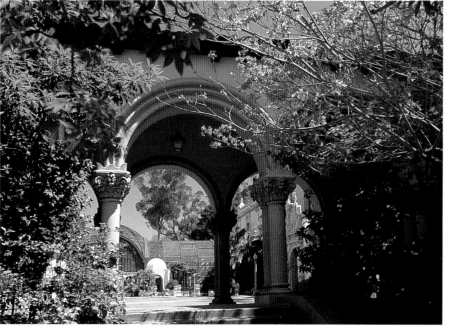

Windmills

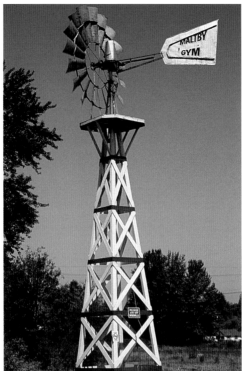

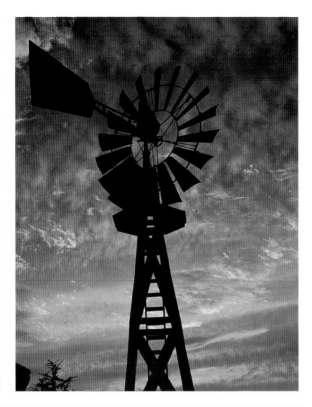

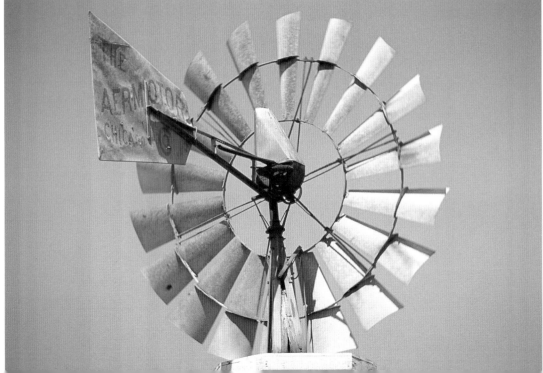

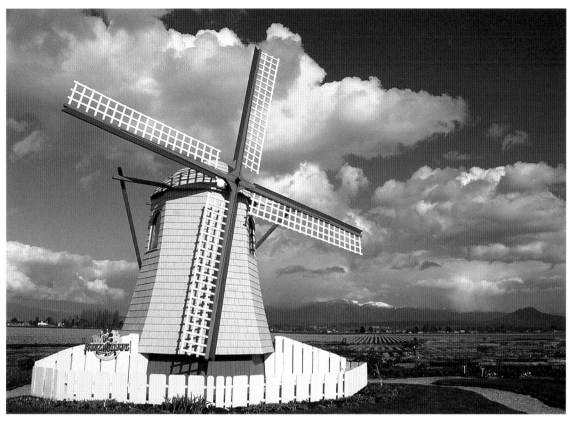

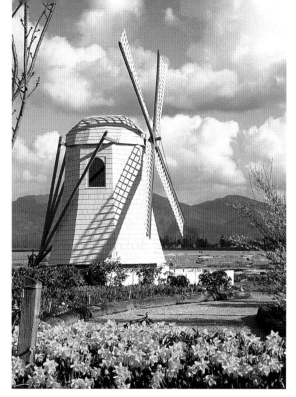

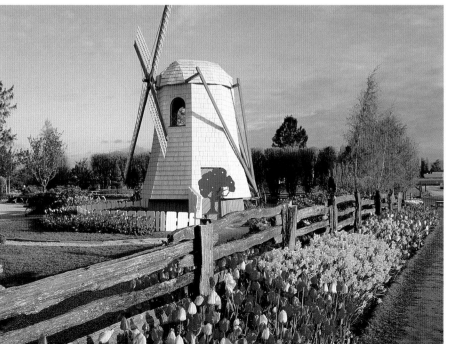

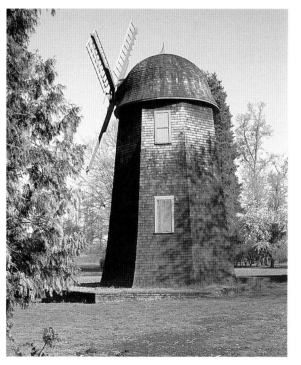

Michele Cooper

"Being an artist seems to be a characteristic, as well as a profession," says Michele Cooper, NWWS (Northwest Watercolor Society). A noted teacher and painter, Michele was born in Spokane, Washington, and has lived in the Seattle area for the past thirty-five years.

Since an early age, she has worked in practically all media: pencil, charcoal, pastel, oil, acrylic, gouache, stained glass, pottery and watercolor. Classical guitar, videography, gardening and aerobic choreography are just some of her other artistic pursuits and accomplishments. She has pursued her art studies through college classes and private instruction with such nationally known artists as Frank Webb, Gerald Brommer, Barbara Nechis and Christopher Schink, among others.

Now with three books privately published and another in the works, plus countless shows, classes and workshops to her credit, Michele has retained all the enthusiasm and joy for her art, which she has felt since becoming a full-time painter. Her exuberance and excitement are evident in all her outstanding watercolors. Big, colorful washes blend with a deft, impressionistic handling of details to create the mood of the subject. This enthusiasm, along with her expertise as an artist, teacher, writer and videographer, has earned her a huge regional following.

Her latest venture is as the webmaster of www.michelecooper.com, her own website. She has also produced a series of watercolor lessons on video.

Among numerous national and regional group and solo shows, Michele's work has been exhibited at the Frye Art Museum (award), Northwest Watercolor Society Annual (award), Watermedia '85 and West Coast Works On/Of Paper.

In the year 2000 she received the Puget Sound Painters Award for excellence in landscape painting. Her painting *Northwest Coast* has traveled in the international exhibit "Women Painters of Washington 1999 Millennium Images—Ireland and America."

Michele is a signature member of the Northwest Watercolor Society and Women Painters of Washington, a past president of the National Collage Society and the author of *Alaska Journal, Easy Steps for Painting Buildings in Watercolor* and *French Canal Journal*. Her traveling workshops have become the highlight of the year for both students and the instructor.

Barbara Krans Jenkins

Barbara Krans Jenkins enjoys working on location, whether it is doing a delicate botanical study or a more elaborate painting. She often selects forest floor microcosms from the abundant flora and fauna around her. Barbara feels it is always important to capture the delicate ecological balance of her subjects in their natural environments. Her favorite subjects come from our lush woodlands.

Her works hang in galleries and in corporate and private collections across the United States and abroad. To date, Barbara's work has been published in six books: *Artist's Photo Reference: Flowers,* by Gary Greene, and *The Best of Flower Painting*, edited by Kathryn Kipp (North Light Books); *Creative Colored Pencil: Landscapes* and *Creative Colored Pencil: The Step-by-Step Guide & Showcase*, by Vera Curnow (Rockport Publishers); and *Introduction to Figure Drawing*, by Philip Wigg (Wm. C. Brown Co. Inc. Publishers).

Although Barbara works in oil, pastels and watercolor on occasion, she prefers the control and convenience of colored pencil (water, oil and wax based) pigments, often over a fine ink contour line. Her love of line is evident in her work, although it is often completely covered with colored pigment by the time a painting is complete.

Barbara has a degree in art education from Kent State University. She has taught art classes and offered workshops while working as an artist for thirty years.

In addition to her interest in wildlife, Barbara has a keen interest in architecture. Her use of freehand line in her home portraits lends warmth to her architectural renderings.

Linda Tompkin

A realist painter by choice, Linda works primarily in acrylics and oils. She uses these two mediums to build up the surface of her work with many layers of paint until she attains the depth of color and the realism she is after. She enjoys the utter freedom that working in opaque media gives her, adding and subtracting, moving back and forth between the positive and negative shapes. Her subject matter is quite varied, but her main focus involves landscape or still-life painting. She is especially drawn to vibrant colors and strong value contrasts, and loves to include intricately designed shapes in her work. Her love of nature is quite evident in her work. An avid gardener, she often includes flowers in her still-life paintings.

Linda was born and raised in Ohio. She has spent most of her life there except for the three and a half years she lived in Northern Ireland. She has always known that art was her heartbeat and has painted since early childhood. She studied with many professional artists during her formative years, practiced and perfected her craft, and has been teaching painting privately for more than twenty years.

Articles about Linda's work have been featured in *The Artist's Magazine* and "WaterColor '94" published by *American Artist* magazine. Her art has

also been published in *The Best of Watercolor 1, 2* and *3* (Rockport Publishers). Her paintings have been included in many national competitions, including those of the American Watercolor Society, the Butler Museum Midyear Show, the National Academy of Design, the National Society of Painters in Casein and Acrylic, and many others. Her paintings are also in many corporate collections, including The Ronald McDonald House and Key Bank (Cleveland, Ohio), Unican Security Systems Ltd. (Montreal, Quebec), Saint Luke's Episcopal Church and Akron General Hospital (Akron, Ohio).

Linda is a signature member of the American Watercolor Society, the National Watercolor Society, the American Artists Professional League, the Ohio Watercolor Society and the Akron Society of Artists.

Larry Weston

Larry Weston was born and raised in Phoenix, Arizona. His parents recognized his art talents at an early age and enrolled him into oil painting classes while in the first grade. He has been painting ever since. Larry and his wife, Shirley, presently reside in a suburb of Dallas, Texas.

While stationed in Germany with the United States Air Force, Larry began his art teaching career. At the age of nineteen, he started conducting oil painting classes for other servicemen in his off-duty time. While in Europe, he painted most of the castles along the Rhine and Moselle rivers in Germany, as well as many scenes from France and Switzerland. After his discharge from the service, Larry enrolled in college and majored in commercial art. During this same period, he also studied and completed the Famous Artists School's Commercial Art, Illustration and Design course. Later, he completed the Famous Artists School's Painting course.

His first art position was with the American Quarter Horse Association as a commercial artist in Amarillo, Texas. In 1964, he moved to the Dallas/Fort Worth area. He spent the next ten years with Teledyne Geotech as their art director. He later went to work for a Halliburton company, Otis Engineering Corporation, as the graphic arts department manager. In 1982 he resigned from Otis to pursue a full-time career as a fine arts painter and art instructor.

To date, Larry has taught over four hundred watercolor and oil painting workshops and classes. In addition, he has conducted several hundred demonstrations for various art organizations. For four years, he was a traveling watercolor instructor for the University of Oklahoma's Continuing Education Department, during which he conducted many one- and two-week watercolor workshops throughout the United States, Mexico and Europe. Larry has also served as a judge for many local, regional and national shows.

As an art instructor for forty years, Larry has always strived to excite his students by showing them that they are better than they think. He loves to introduce students to new approaches and painting techniques while still adhering to the basic principles that constitute good art. Larry has taped over fifty weekly TV programs titled "Adventures in Watercolor."

Larry's peers consider him a master of his trade, and his work has received numerous national and regional honors and awards. His paintings hang in major galleries and private collections across the country and in Europe. He's a signature member and a former president of the Southwestern Watercolor Society (SWS) and an associate member of the National Watercolor Society, as well as many other well-known art organizations.

Frank E. Zuccarelli

After serving in the United States Marine Corps, Frank attended the Newark School of Fine and Industrial Arts in Newark, New Jersey, where he later went on to teach pictorial illustration and painting. He received his B.A. from Kean University, New Jersey. In 1984,

Frank was named to the Pastel Society's Master Pastellists. In 1996, he was named an honoree in the Pastel Society of America Hall of Fame, New York.

Frank has exhibited internationally and has conducted workshops, as well as given demonstrations and lectured in the United States and China. His favorite mediums are pastels and oils for which he has received numerous awards. His most recent awards include the Silver Medal of Honor, Allied Artists, New York City 1995; the House of Hydenryk Award; Pastel Society of America 1998 President's Award; American Artists Professional League Grand National 1998; the Salmagundi Club Prize 1998; the George Maynard Salmagundi Club Award 1999; and the Bruce Crane Salmagundi Club Award 2000.

Frank has written several articles, including "Take Control of the Landscape" and "The Perfect Surface" for *The Artist's Magazine* and "Improving Nature's Landscapes" for *American Artist* magazine. His work has also appeared in *The Best of Oil Painting, The Best of Pastels 1* and *2, Landscape Inspirations* and *Floral Inspirations* (Rockport Publishers) and *Pastel Interpretations* (North Light Books).

Frank's work can be found in some select collections, including the United States Navy Department, Washington, D.C.; the United State Marine Corps, Barstow, California; Emigrant Savings, New York; and the MCC Corporation, Murray Hill, New Jersey.